IN PLAIN SIGHT

AMY BRETALL

Faith Is In The Everyday

Dedication

——

To my Mom and Dad, Judy and Bill Bretall, for raising me in faith.
For instilling in me a pre-faith, before I knew
to develop my own.

Introduction

———

Faith. We all need it.

Whether it's faith in ideas, communities, relationships, nature, religion, or ourselves. Where do we find faith?

In Plain Sight encourages spiritual self-development, to seek faith in everyday life. The original photography and inspirational messages are intended to help discover, develop, deepen, and renew our spiritual connections.

Exploring symbols found in our surroundings, specifically the Cross, this collection offers new ways of seeing and experiencing faith.

In today's fast-paced, largely secular society, there is a need for uplifting imagery that connects us to a higher power and purpose.

The everyday crosses featured in this book show us that even in the most unlikely places, faith is present. *In Plain Sight* challenges our understanding of the Cross, that the symbol of faith is not bound by location, but can be seen and experienced in the obscure and overlooked.

Raised Up Faith

Las Vegas, Nevada | 2018

This little raised cross. Torn marks cut deep all around leaving scars like I've felt in life. But it doesn't define me. The cross within me remains the stronger beat.

"Raised up, reclaimed, repurposed, redefined, rejuvenated, stronger for the marks. That is how good the Cross is. Redeemed."

Keeping a positive outlook in life can set your direction. My Dad helped form this perspective early on with his ongoing upbeat nature. It was my "pre-faith" faith. The first struggles I really had in life were health-related, being diagnosed with ulcerative colitis, an auto-immune disease, with no cure or known cause. It was embarrassing and painful many times. I was hospitalized the month before I started college for a rare reaction to a medication. Then two years later I had to drop out of a college semester due to a bad flare-up. These health struggles, and forced recovery times, when all I could do was rest, helped form my determination.

Sometimes the marks life leaves are visible too long, a reminder of the pain. Failed relationships, false securities in a job, loss of those we love, and other things life throws us. But I won't stay there. It would have been easy to give up, but you can't. There is always more. More for us, more to give and more to learn. The grace of the Cross. I now see this positive mindset as a fundamental element of faith. Do good. Believe. Hope. Trust. It was part of my faith foundation before I even knew to discover and form my own personal faith. Starting small with the size of a mustard seed, faith grows. The little things in life are big.

That's how good the Cross is. This cross image, found in concrete, is seemingly tossed aside. The outcome is the formed in the unformed. It is a powerful reminder for what the scraps and unintended marks can make – we are an art form in the making. Raised up, reclaimed, repurposed, redefined, rejuvenated, stronger for the marks!

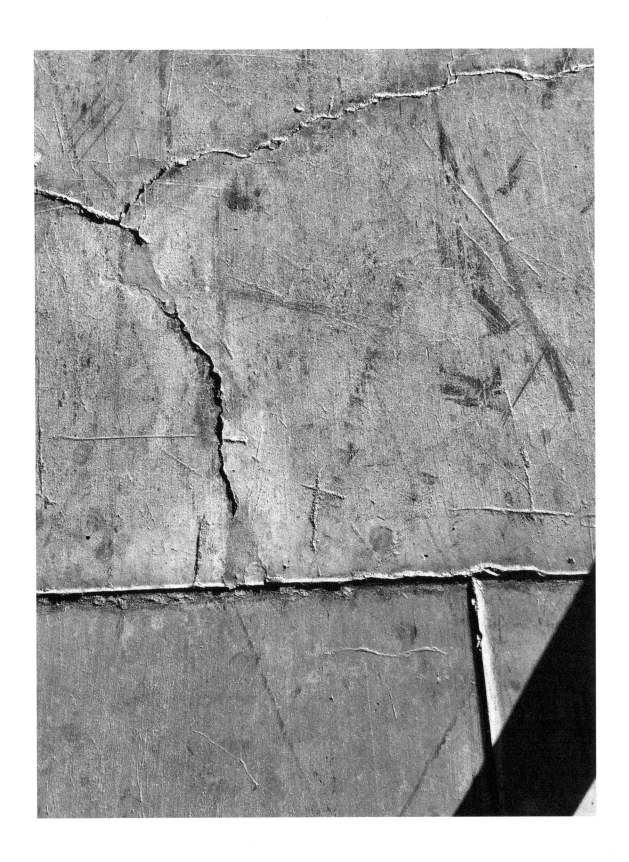

Step Out

Kansas City, Missouri | 2018

Do you ever wonder what you're missing, not seeing, or overlooking? Things right in front of you? I do.

I've used these steps in my walk route for four years. For two years I've been very aware of seeing the unformed cross, but this one was right under my feet!

Even when I'm used to see crosses formed in the non-traditional way, the everyday cross, I'm still surprised where I find them. A cross, right there on the steps I've crossed so many times. I just had to notice. I just had to "see" it. And I had to "know" it in order to "see" it. A statement of life. What else do we overlook in our daily walk, in our daily rush, in our day?

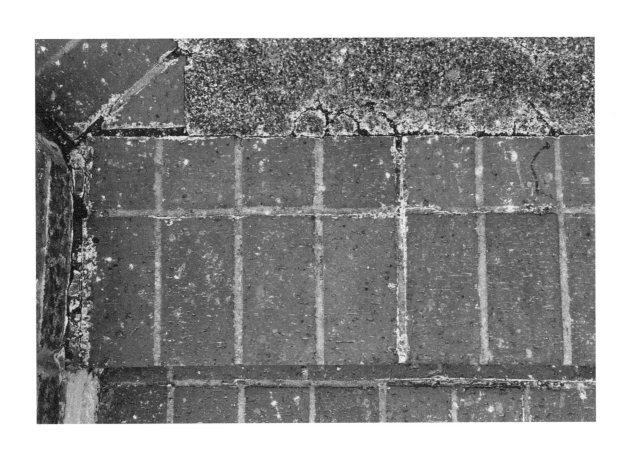

Shadow Showing

Kansas City, Missouri | 2018

The power of the sun to transform. The power from above to show us a new image, all it takes is the mix of nature and time. The light source casting a different perspective for us to see. What is our view?

Is our shadow casting an image of powerful faith or pitiful faith? I'm reminded of Oprah Winfrey saying "You can't be powerful and pitiful at the same time." Is there no middle ground? The Bible says there should be no lukewarm, you're either hot or cold.

It doesn't take much to swing one way or the other. What you think about matters. That's the same with faith. How does your inner voice speak? Does worry and anxiety overcome your ability to find peace? For me, peace comes from believing in a higher power and constantly challenging my muscle of faith to get stronger. No, I won't let that second of doubt linger. No, I won't let negative self-dialogue enter my mind. Yes, I will turn to prayer. Prayer and believing brings me peace in the storms of life. I will turn to my belief that God is bigger. A powerful faith.

What shadow do you cast for others to see?

Photos on page 7/8 — Kansas City, Missouri | 2017 — Kansas City, Missouri | 2017

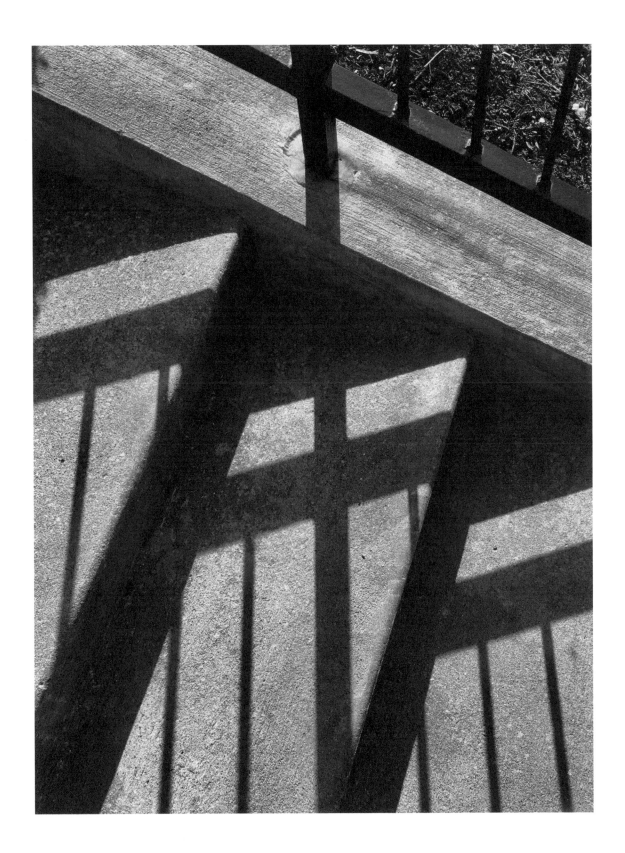

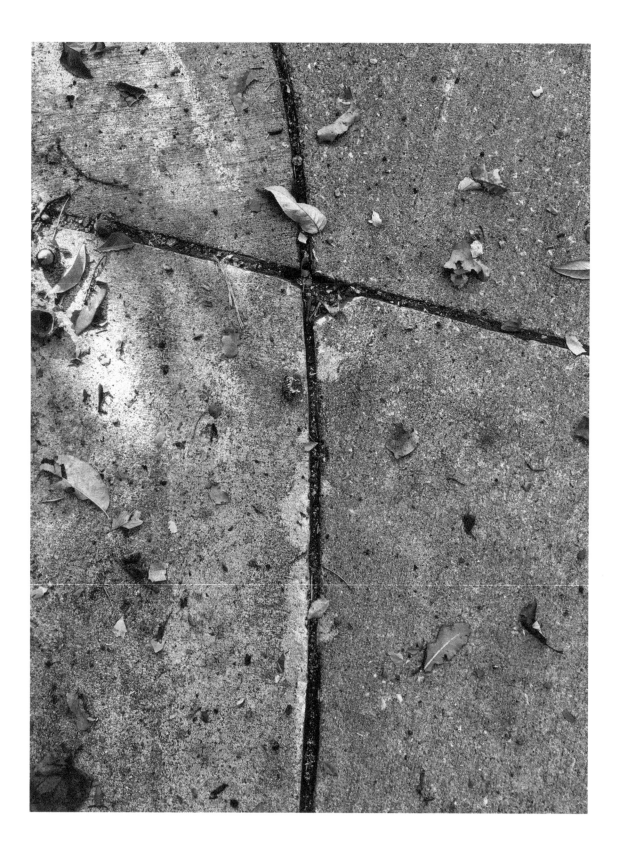

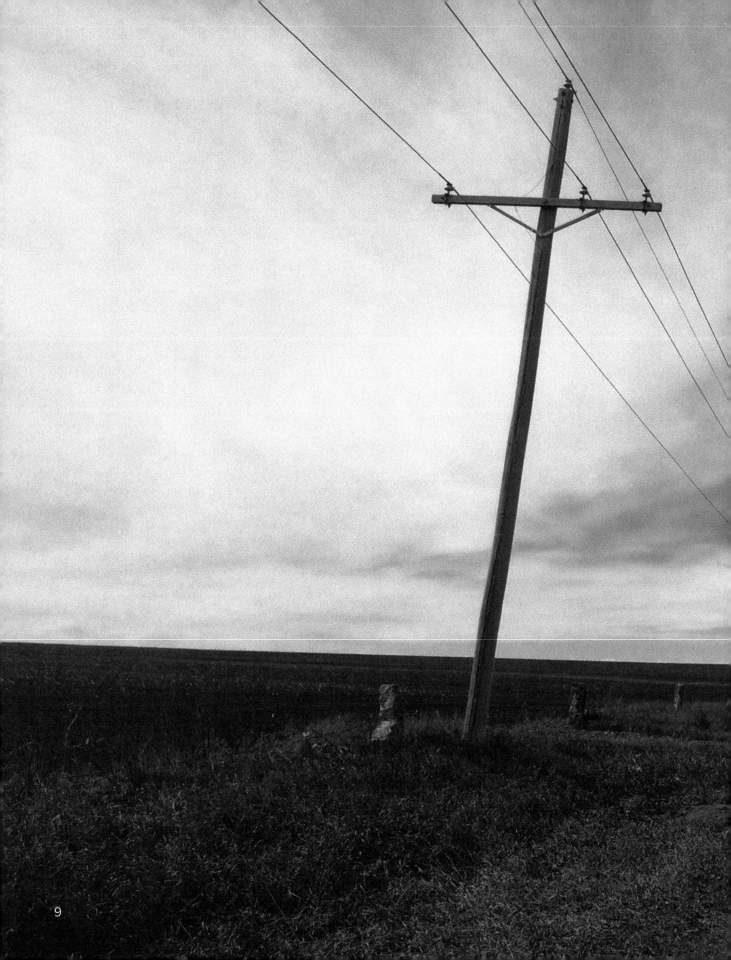

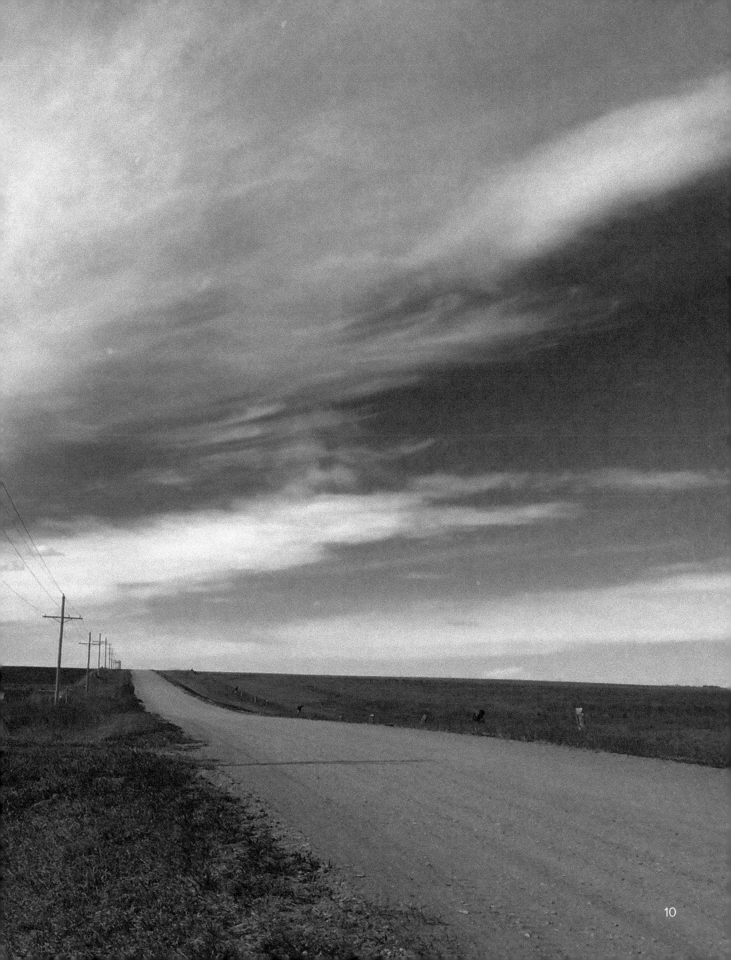

Electric Pole Connections

Gordman, Kansas | 2016

The road ahead. It's not always the easy path. But in life, for your only life, why not take the chance? It takes persistence and a steadfast focus to listen to the beat in your heart. And to then follow that beat!

And it most definitely takes faith. It's your vision, it's your gift, it's for you to do. Sure, you could stay in your comfort zone but, that inner voice will call again. Don't silence it. Breathe in faith.

When I first had this idea of taking some of my photos and turning them into greeting cards to help a little girl I met in Cuba, I joked with a good friend "Hey, and if nobody buys these, I will have a life-time supply!" And I was just fine with that. I love sending cards to people who matter to me. But something happened along the way. This little seed of faith grew. I believed. I printed the photos in larger sizes and framed a few.

I sold my very first framed print without even trying. I say this with a humble spirit. In the beginning I participated in a small, informal art display at the YMCA. I didn't feel ready for it, but put five framed prints together. An hour before the event I created a flyer and had it printed with another one of my images that was not on display. During the evening a woman stood looking at my work. I walked over and asked what she thought. She said: "The photos are so authentic." She asked if I sold my work in a gallery, and then purchased the Electric Pole Connections framed print." This photo – my first one sold – has turned out to be one of my best sellers. You have to faith it!

I was lost on back rural Kansas roads when I saw this pattern. Like the great song Amazing Grace, "I once was lost, but now I'm found." The Cross on our road, right by our side, a constant, never ceasing.

Our road of faith.

Salt Formed

Kansas City, Missouri | 2018

Well, aren't you a cute little cross? Just hanging out, left from the salt crystals of winter. Not a left-over. You are left for seeing. Left for finding. Left to be a *Lift*. You are a *Let me be seen!*

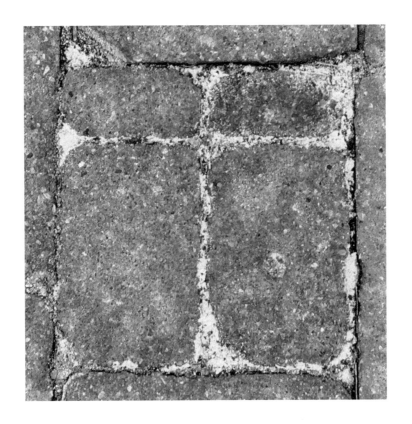

Reserved Parking

Shawnee, Kansas | 2018

Something about this photo draws me in. Seeing a cross in the parking lot stripes, You once again just show up. As the snow melts and the pavement is marked with salt streaks, there is beauty in the pattern.

And there is beauty in our story, even when there is pain. You will wash away the tears from our cheeks. Tracks remain from others that have steered us around. There is something more.

Because we are reserved. We have a space. The lot is not full. We have a place within faith.

You are all around.

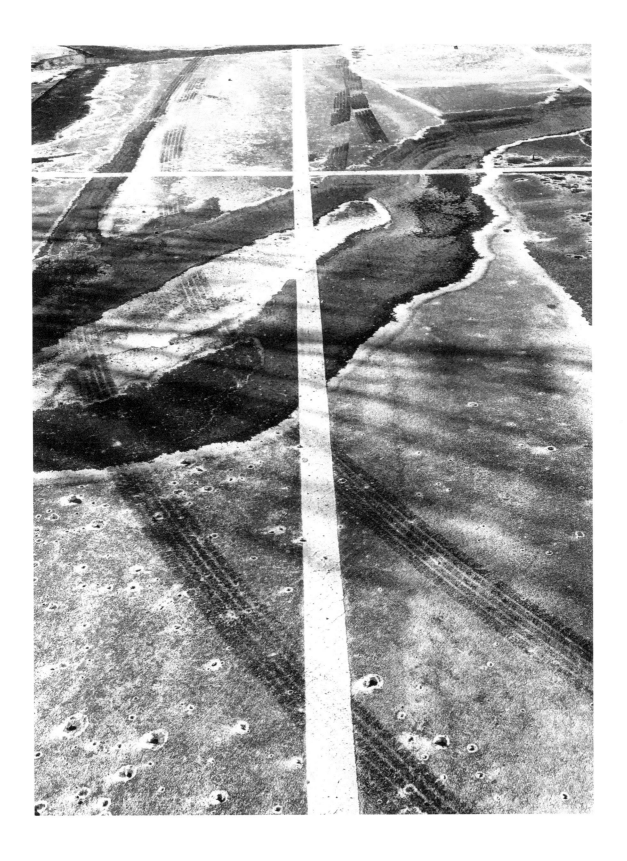

Street Sighting

Kansas City, Missouri | 2017

I'm on the treadmill. I pray while looking out the window and exercising, my eyes are fixed and steady on a spot. In my time of prayer, I glance just a few inches to the left, and I see this image on the street outside. A cross. Arms reach out gracefully.

I've been at this same spot many times before and hadn't noticed this cross. Did I not look? On a treadmill there is only one way to look – ahead. But I was busy, occupied in other thoughts, listening. This time I was praying, asking.

If we are open to the power of prayer, what can we see? If we seek, what can we find?

Photo on page 19/20 – Kansas City, Missouri | 2017

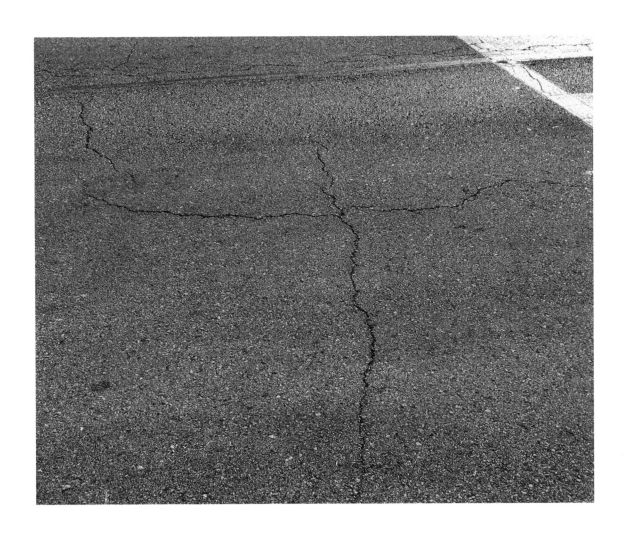

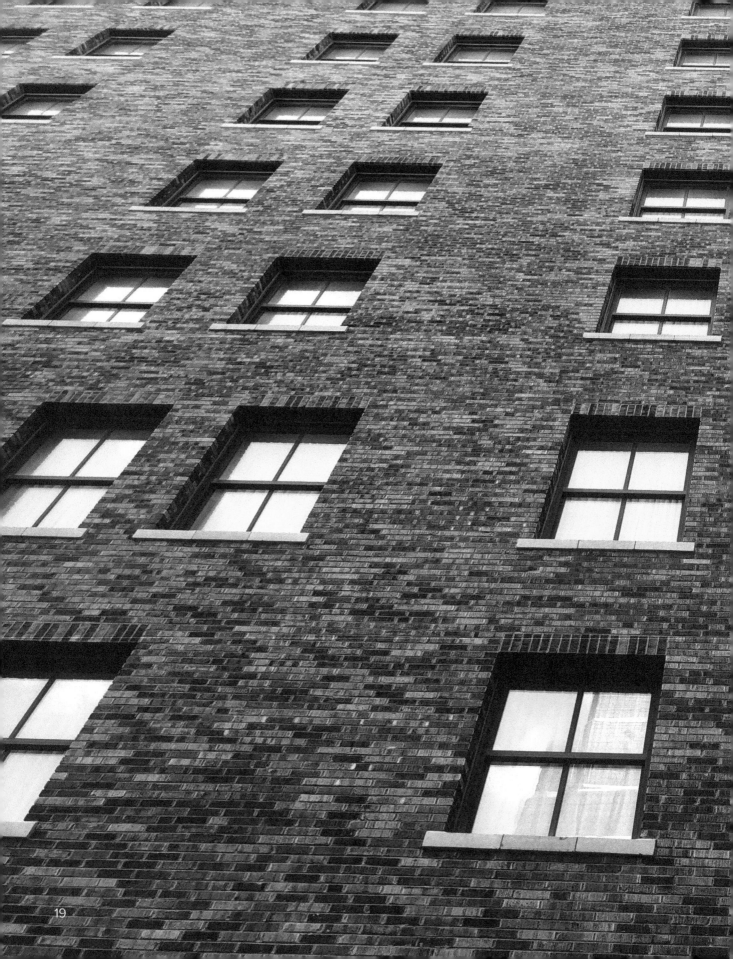

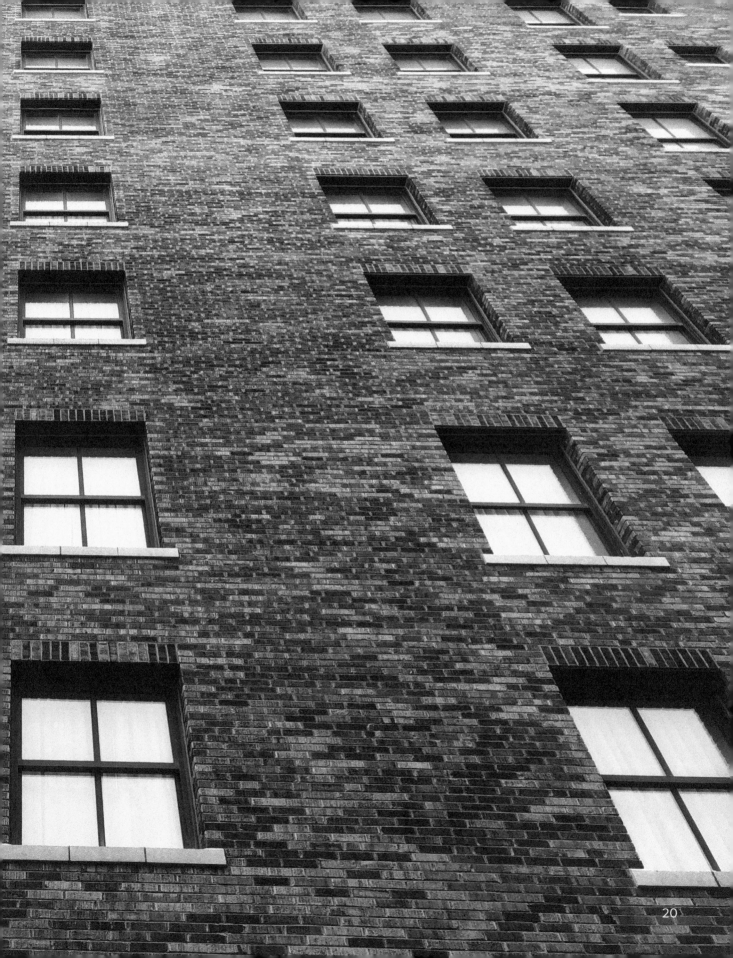

Nature's Signs

Kansas City, Missouri | 2018

Two twigs. Sometimes it doesn't take a lot. Like this small cross — formed from two twigs.

Little sticks fallen from a beautiful tree, one on top of the other, just so. A reminder of an imperfect perfect order of nature. Maybe not everyone would see it. It's not an exact cross form. It has a little extra style, like it's in italics for emphasis. I Am here.

It doesn't take a lot for us to be reminded of a higher power, or to have our spirit refreshed. The little things in life can be big and nature brings these signs all the time. Signs are all around us. Do we take time to see?

Being in nature is part of my faith walk. The original creation, nature is a spiritual pathway.

There isn't a right or wrong start, but there is significance to the path we are on. The curves, detours and roadblocks that will come along our way and the persistence to stay. To stay on. To stay above. To stay in faith. What faith walk are you taking?

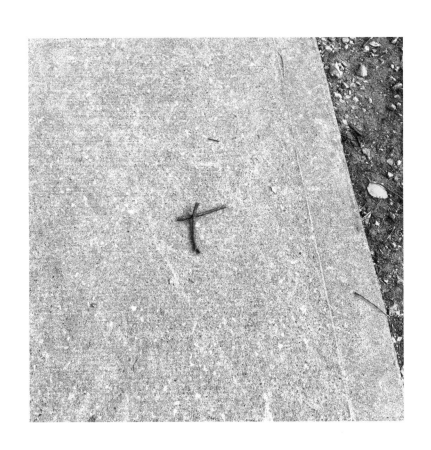

Faithful Shadow

Kansas City, Missouri | 2018

I was out for my usual walk, but went at a different time of day with a slight variation on the way back and there it was. Since this sighting, I've been by this section often, looking at this spot, and no image, not even a slight shadow.

Seeing this shadow cross during my routine walk I was praying, thinking about a faith project, being led, not knowing the how, but knowing to do. And then, I see this image. Coming across the universal symbol of faith in nature is powerful. Seeing a cross in nature sends me a message.

"You will seek me and find me when you seek me with all your heart."
- Jeremiah 29:13

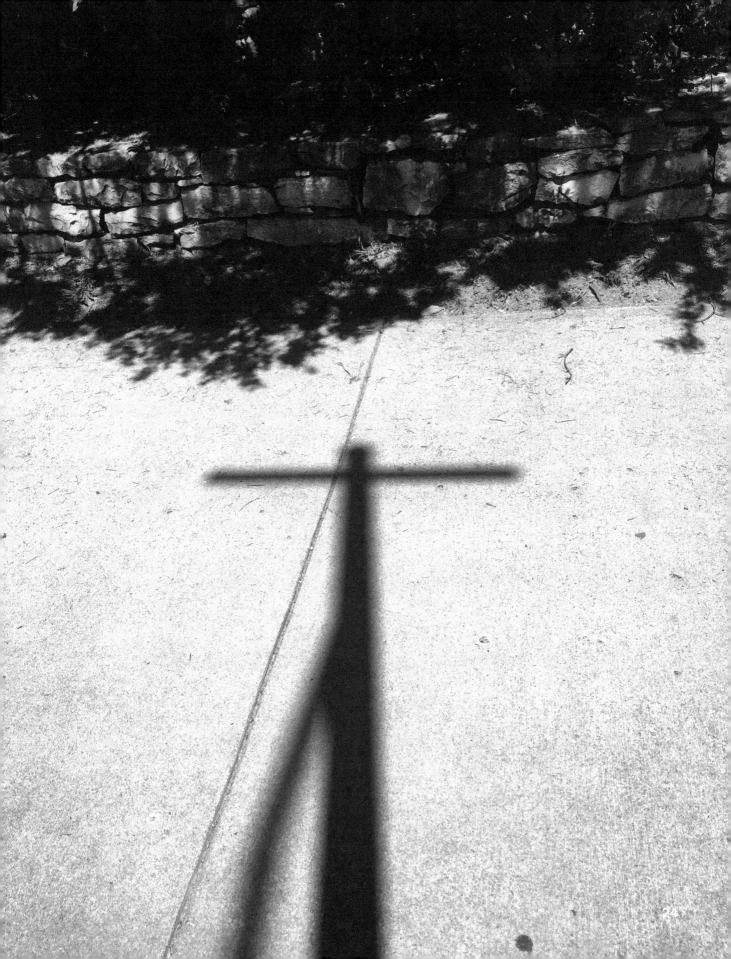

Formation

Kansas City, Missouri | 2017

I see You. Seared into the concrete road, cut on the sides like many of us feel in life. Crumbed bits of fallen leaves trace a side of You.

The cross formation comes together by lines that didn't start for You. But You came through anyway. It is of You, from You. You show that through the pieces, bits, cuts, scraps, and the scars- the stuff that can bite, leaving a lasting wound, You show up. Like faith, we can start at any time; it's fine if we didn't begin with, it. We can always turn towards and be formed.

Showing strength. Showing presence. Showing resilience. You can't be wiped away.

It says "I Am" here. Like life, we make it what we see. You can see just the cuts in a road or you can see a cross which stands for hope, life, transformation, and more.

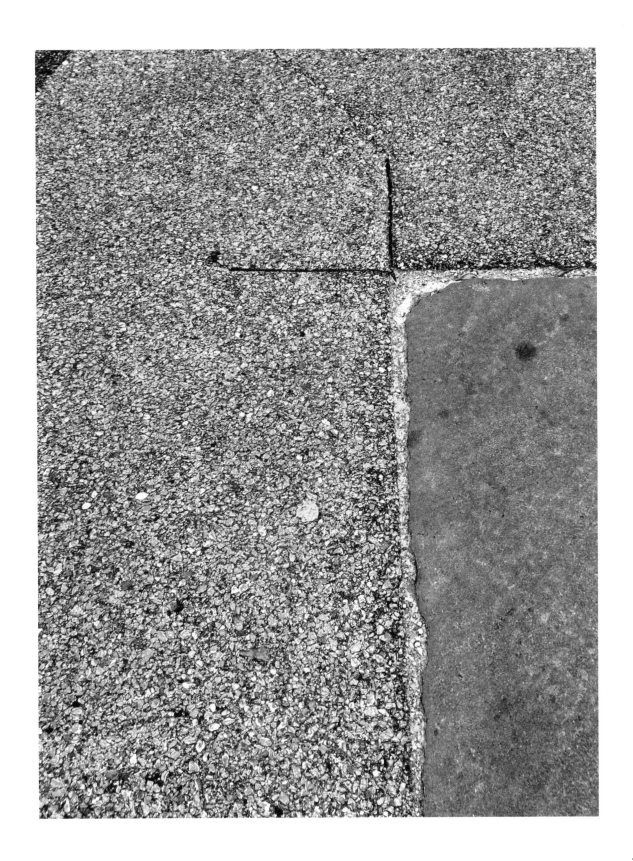

Crosswalk

Springfield, Missouri | 2016

What do you see on your path?

Don't underestimate the power of a few people to help push you along the road of your idea, your dream, your passion.

Not everyone will see your vision. Or buy into your idea. And that's okay.

You have yourself. And God has a pretty marvelous way of providing encouragement too.

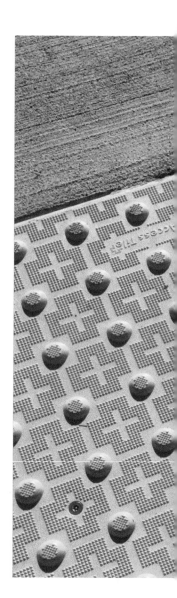

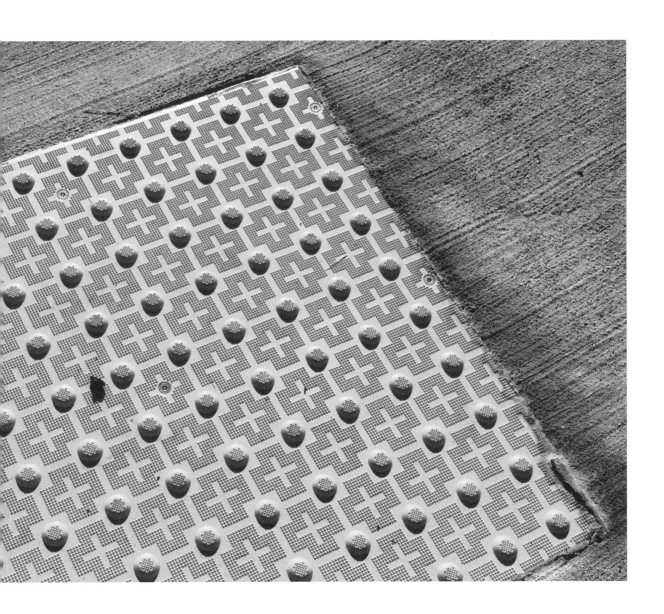

Show Me The Way

Kansas City, Missouri | 2016

It was for me to see. While walking, I found it, something meant for me. Has this happened to you? Finding or seeing a symbol in nature? I think this is the best kind. A large thunderstorm passed through the night before and debris was all around. I almost went a different way on my walk, but veered to a little loop.

This was one of my very first "every day" crosses. At this time I was new in my pursuit of the cross, compelled to take photos of crosses, but I didn't really know why. The month prior an idea came to me to turn my cross photos into something. What if? Yes. I was praying. Seeking.

And there You were. On my walk, I saw You. To me it was a sign telling me you are on the right path. Like the scripture I had been reciting, Psalms 143:8, "Let the morning bring me word of your unfailing love, for I have put my trust in You. Show me the way that I should go, for to You I entrust my life."

Timing. A few steps on the delicate pieces and the form shifts, the content moves, changes and evaporates. It was for me to see.

Talking with my Dad later, I shared the sighting of this cross and as we closed our conversation he said, "Keep looking for those crosses." A good daily outlook.

What are you looking for? Are you seeing what is in your path?

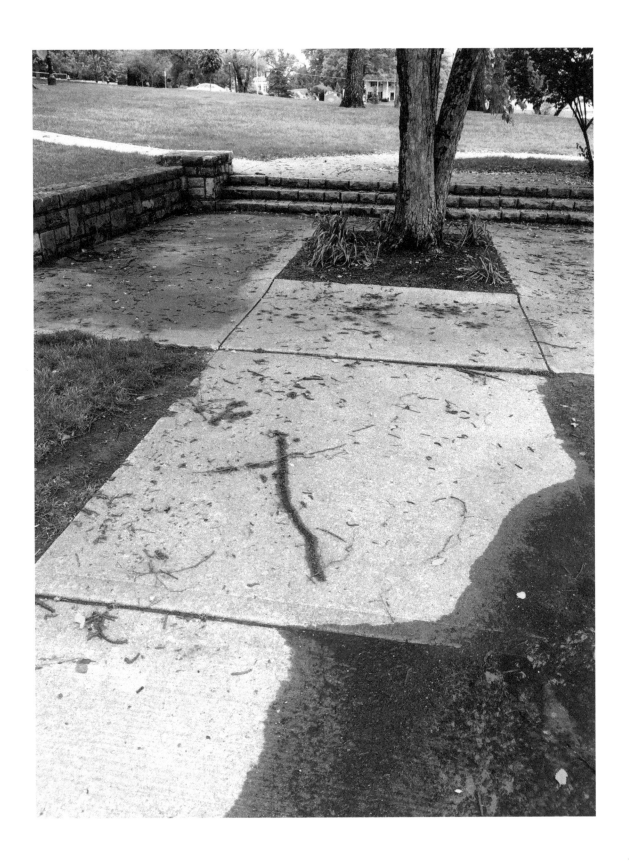

Farming Faith

California, Missouri | 2015

What do you see in this photo?

At my grandparents farm the day it was sold, I was going through all the old barns and sheds, one, last, time. Just me and the farm. Soaking up the memories of summers there, exploring the beauty of the old structures. Timeless. The beauty of rural America.

I didn't consciously realize the wall boards were full of cross images at the time.

And that is the nice subtlety of the Cross. It's there even when you don't know it. Surrounding you. Being present, even if you aren't.

Just waiting for you to see.

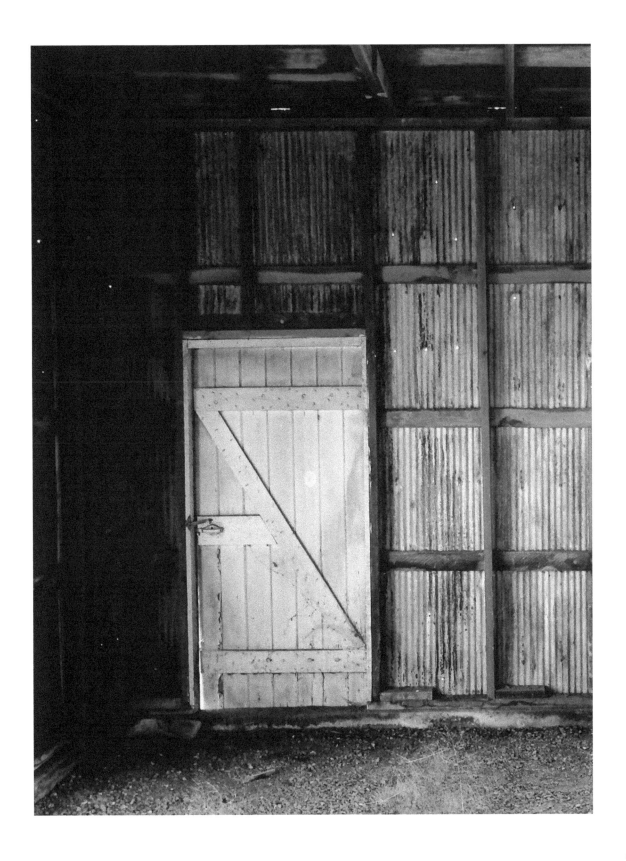

Inner Faith

California, Missouri | 2015

Sometimes you don't even see it. You can feel the beauty, the photo, and know it's right. Then later, something more appears.

In this photo the cross is all around. I shot it at my grandparent's farm before I was intentionally taking photos of crosses. Isn't that like faith sometimes? It's there for us, always waiting for us to see.

Breathe in faith!

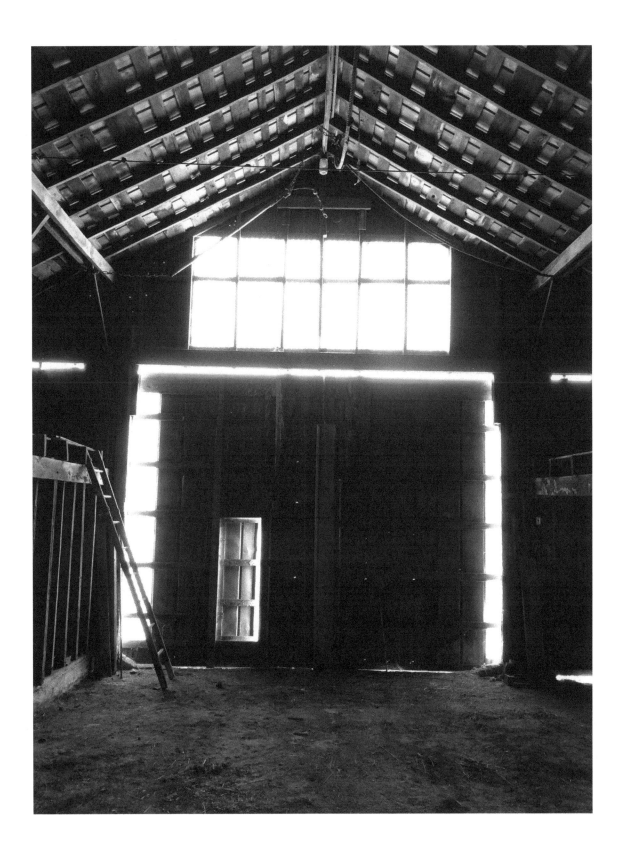

Faith Signs

Victoria, Kansas | 2016

Sometimes you don't know how it's going to start. But it does. You start the "doing" without even really "knowing." And then, along the way, a development occurs. An idea. Do you listen to it? Or do you brush it off? Does your heart keep chanting it to you?

A few small steps of taking action on an idea moves it forward. That's all it takes. It doesn't have to go far at first. Just enough for you to feel it. This is the start.

For me, I began taking photos of crosses. I don't know why. I was just compelled and I listened to that inner voice. I'm not a photographer; I used my iPhone. This is the "doing" without "knowing" stage.

Once you get started, then the stages of how bad do you want it, will rise up. Early on I remember my first hurdles were figuring out pixels, receiving different colorings of ordered prints, the re-sizing of square images to a 4x6, etc. I was frustrated and I set the project aside for several weeks.

Faith doesn't let you see everything. That is why it is called walking by faith, not by sight. At that early-on time, I shared my frustration with my dear adopted grandmother Jean. I told her I was asking myself 'How important is this photo project to me?' and I realized if I did not do it, it wasn't going to get done. And you know what sweet Jean said to me in her gentle, knowing voice? "I think you'll do it."

A few more weeks went by before I picked the project back up. I was drawn to it. It was for me to do. And today, that little cross photo project has turned into my mission. The project culminated into a sermon interview with me speaking about my work with the cross and an art gallery show. Yes, Jean, I did it. It was for *me* to *do*. And I continue doing it.

What's in you to do?

Faith In Action

Victoria, Kansas | 2016

I've learned that what starts small can grow big. An idea, a passion, or a little bit of faith. As you lean into it, spending your time, your effort, your energy, it grows. Like watering the mustard seed. All it takes is a little bit every day.

I had a pretty neat thing happen to me. Following the belief of "Knock, ask, seek," I did.

I asked a pastor at a church I have attended a handful of times over a span of eighteen months if he would meet with me so I could share a passion project God placed in my heart. We met and he took time to hear my journey and what I was trying to do to get more of the cross in the world. I asked if I could speak to one of their small groups. He was receptive and appreciative of my work and said he would think about it. Several weeks later he emailed saying my project sparked an idea for a sermon series on symbols. He would like to have a sermon on the Cross featuring my work and interviewing me.

I asked to share with a small group. He came back with speaking and sharing my crosses at two sermons! Over 200 people! That's how cool God is!

Faith in action. I don't know all the hows, but I keep going. Forward momentum. Faith, entrepreneurship, and perseverance.

What's your showing of faith?

Sights Above

Kansas City, Missouri | 2017

And just like that. There You are. Deep and wide like Your love. Stepping out for a walk this week I am greeted with Your reminder. Nature brings them if we look.

When we are down, where do we look to keep above? To stay above a challenging season, a disappointment, a hard time whether in the form of an illness or loss? Just to keep above?

It's timing. Seeing a cross in clouds on a windy day, the images shift and move. Minutes later it dissipated. But this time, this was mine. For me to see. For me to receive.

Let us keep our sights above.

Keep Looking Up

Kansas City, Missouri | 2018

Driving to meet a faith-filled friend, I was excited to spend time with this strong woman, fit in faith, amazing mother, entrepreneur and encourager.

I was thinking about several big goals, big dreams in my heart, with my faith project to inspire faith. Then I see this bold beauty in the sky. You are so good! Pointing the way.

Along my faith walk, so many times when I've been thinking about what I need to do next on this mission, I'm thinking, and I'm praying, I see an everyday cross. It's pretty amazing! I receive it as a sign from above. It's a special gift. I receive it as confirmation to keep going, encouragement I'm on the right path.

As we search for our mission or life purpose we may expect to hear something, a voice. I did. I've learned God can speak to us in all forms of communications. To me, it is visual signs.

All along the way I have signs from You. I'm thinking I don't know the "how," but You do. Trust. Faith. Believe. I will keep moving forward. Divine direction. You are our GPS.

Photo on page 43/44 – Kansas City, Missouri | 2017

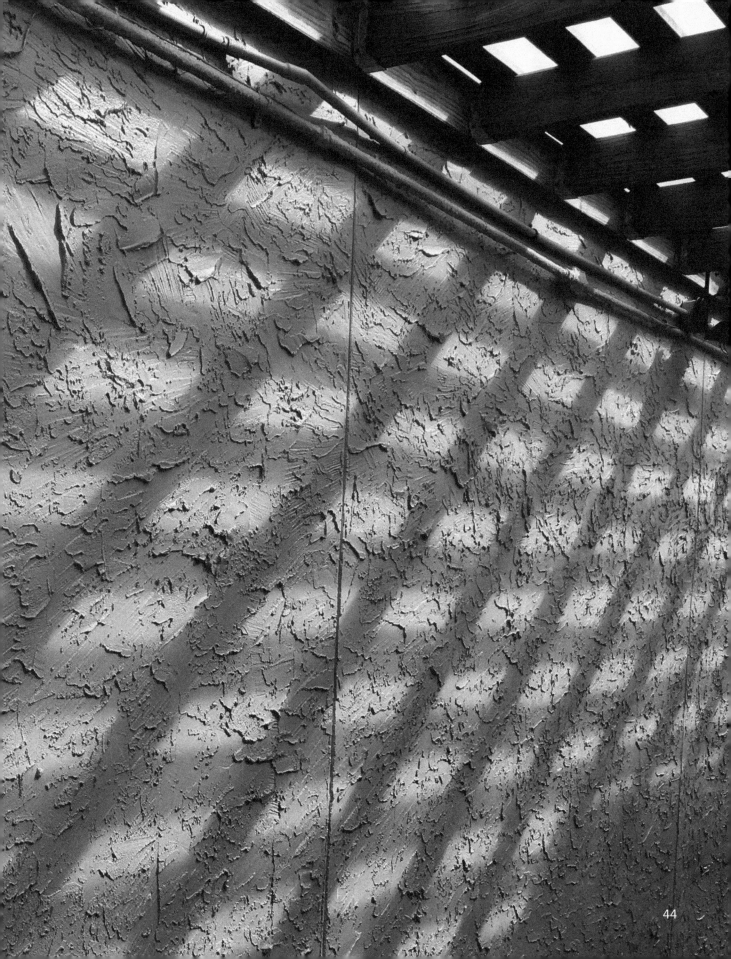

Cracked But Not Broken

Africa | Nairobi, Kenya | 2019

Broken, but not in pieces. In parts, but not falling apart.

Because even broken, we are full of shape. Not taking away, but giving us fullness in a higher power.

Cracked and what some would say is broken, this stepping piece still provides support and strength, surrounded in community by others that are not perfect in form, but perfectly loved. Isn't that the way with us in life?

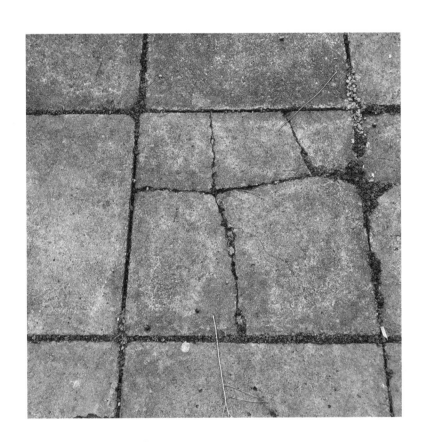

Stepping Faith

Africa | Arusha, Tanzania | 2019

Stepping stones form a walking path with tuffs of grass filling the blank spots. What fills our blank and empty spaces?

Finding this image, the green cross captured my attention. Green is a color associated with growth, renewal, and life. The Cross is a symbol of faith associated with living and being alive.

It's renewing to see our faith on visual display. Nature, as the original art form, showing up and stepping out in style.

Stepping up, stepping out, and stepping over barriers to keep on the path of faith. Stepping to my internal heartbeat of faith. Stepping up to the call I hear. Stepping forward to the obedient actions. Stepping out of the comfort zone of tradition. This green cross appears as I continue to step in faith.

Step by step, faith helps keep the pace in life, the motion forward, and the steady cadence of perseverance. It just takes one first step, with the courage to have faith.

A combination of the green grass and the Cross renews. It revives. It steps in to fill our empty spaces. Faith is alive.

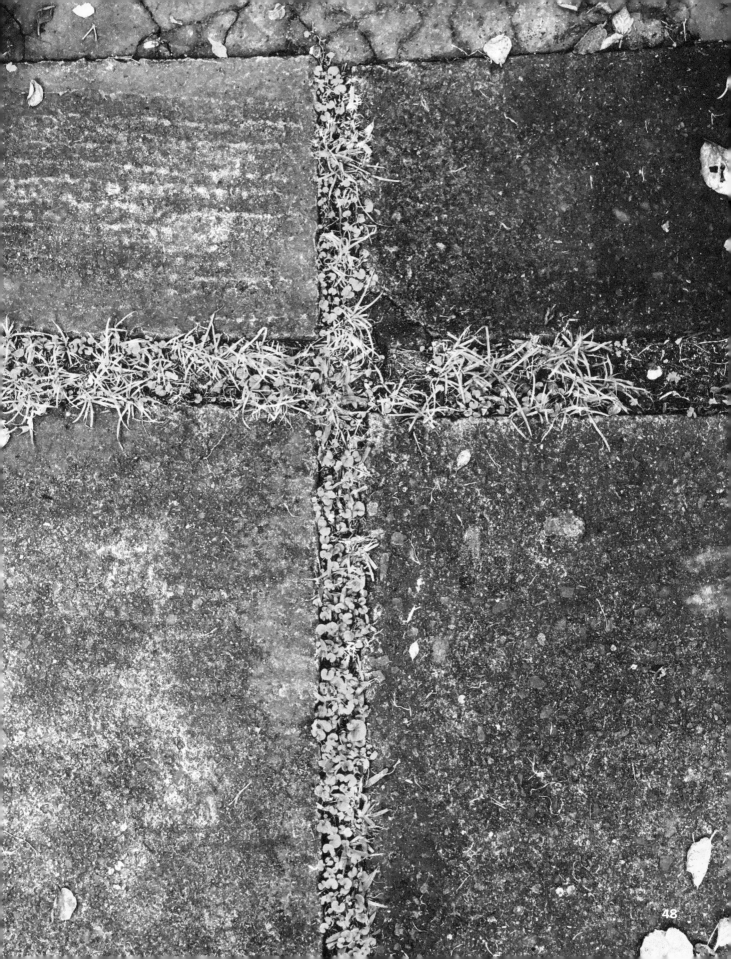

Faith In Abundance

Kansas City, Missouri | 2019

When I first started posting cross photos on Instagram, I thought I would do so once or twice per week. That seemed doable. And then, somehow, it naturally turned into five times a week. Along the way I wondered if I had enough photos of crosses, the formed and unformed. What if I run out? Do I have enough to keep this up? Doubt is the devil, constantly lurking. I consciously made the mindshift to believe in abundance. Just like that. There is not a scarcity. Yes, I have plenty of crosses. I believe I will see and find more. It's having faith in the abundance.

Once I made this shift, something cool started happening. As I posted everyday crosses, those formed in the unformed, people started sending me photos of crosses! People I knew, and some I didn't know, told me they found an everyday cross and thought of me. People also forwarded me beautiful formed crosses. It started with being tagged in an Instagram post from someone who hadn't "Liked" my photos. I first thought it was a mistake. How does this person know @ livebreathalive? But it was intentional. The image was an "everyday" cross of a windmill. A new one I never thought of. Oh, the power of community. The power of abundance.

Subconsciously, there is power in images, even if only viewed for an instant. I keep posting photos of crosses because I hope it reaches people on some level. Even if a person doesn't believe in God, people have faith in something, right? And maybe, just maybe, the images can help connect to a higher power, to inspire faith.

My Bible footnotes state, "God takes whatever we can offer him in time, ability, or resources and multiples its effectiveness beyond our wildest expectations," (John 6:13). We take a first step and more is brought. May we have faith in abundance.

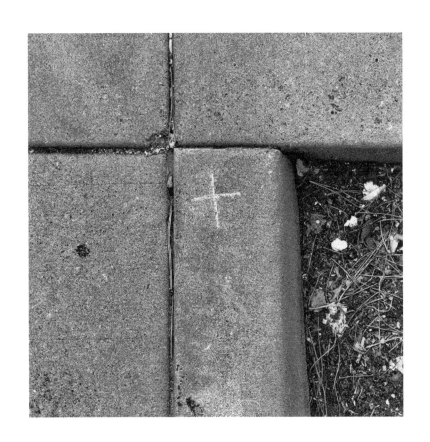

Soft Faith

Kansas City, Missouri | 2019

I tried soft faith. But it didn't work.

I call it soft because it's the kind of faith that's lukewarm and easy. It's when you say you are a man or woman of faith, but still act in the world of convenience and ease. You do when it's easy. You trust when it fits what you understand and want. You believe when it follows your own plan and goals. It's taken me awhile to really follow and be obedient.

Instead, of soft faith, I choose real faith. One that we follow even when it's hard.

Are you following? Or are you chasing? Chasing a feeling? Chasing an emotional need of connection? Chasing love? Chasing something that never quite holds because you just move right on to the next?

Chasing the worldly goods that tells you: Yes, you are successful. You are really doing something. People really like you and "follow" you on social media – look at all your likes. What a great life you have. Look at you.

Look at Me. Do you see Me? I'm all around you. Slow down, stop looking for constant attention and chase Me.

Chase eternity. Chase God's love. Because My love will never let you down. And once you meet Me, it's a fine trickling of attention that just keeps getting better. A love that doesn't fade and will go the distance with you.

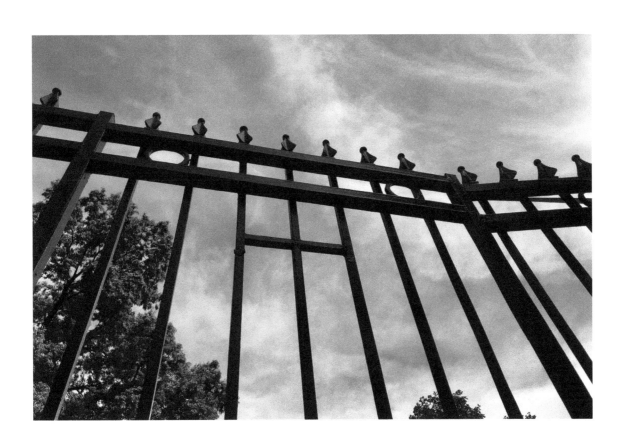

Abandoned But Not Left

Kingsville, Missouri | 2019

You are so crazy good.

Showing up in the discarded, forgotten, dirty, shattered, and left-behind. Your presence is all around, broken glass and a small teddy bear. It was a purposeful place once used by many, needed for refueling, now used by none. And it shows the test of time, deserted.

Except in the midst of the ugly and unknown, You appear. Re-filling our spirit. A tank that needs attention.

Seeing this everyday cross is another one of those times I wonder if I'm the only one. To catch You in the everyday. Driving, I'm talking with a friend about some hard realities, I glance left and in a second see this symbol of faith. So fleeting, but real, I saw Your bold image. What does this image say?

Your life is in front of you. Do you see it? It grabs for our attention. And shows us a stark contrast within our lives. In all this ugly and broken you may be facing, I Am here. Right here. Waiting. To shake us awake. To show us love.

And I laugh. In a rejoicing way. In a "You are so good" way. It's always Your way. Your timing. What else will You present?

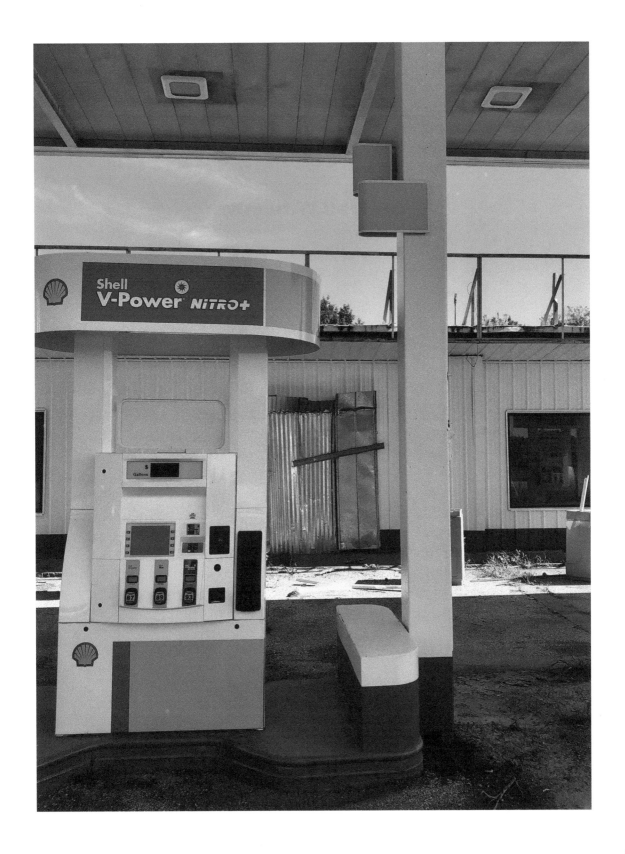

Covered With Love

Kansas City, Missouri | 2020

On this day, at this time, You've been here all along. I've walked by countless times, stepping near, stepping on, or stepping over. But this morning, glancing at the rightly placed and timed step, I see You.

How does it happen? You keep surprising me with grace and showing up.

With purposeful thoughts I walk during normal daily activities and then my eyes see You. It's another gift. Yes, I'll continue to be faithful. You know what's in my heart. You gave it to me.

It's a built-in self-defense system circling our faith. It takes strength and a special tool to open a manhole cover. To open our faith also takes a tool of leverage, called belief. Designed to protect and covered with love.

It's all how a person sees it.

Faith is in the everyday.

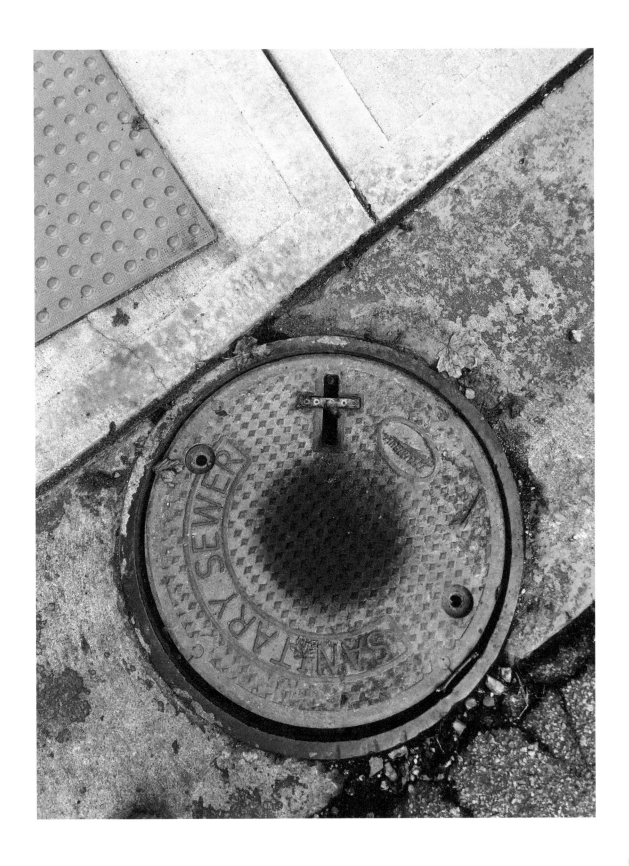

Pause Is Preparation

Kansas City, Missouri | 2019

It started right after a solo gallery of my photography. A creative process that left me wondering, "What's next?" Enter a time of "Pause."

What is "Pause?" Well, for me, it is stillness. Listening from within, an inner *turning* instead of an external *tuning*. It's quiet, as in not having a reliance on sounds. Yep, no background noise of TV, YouTube, or even music at home. It's just being in stillness. My body absorbed it. Stillness IS underrated. Like many of us, I'm focused on progress, goals, and checking off my to-do list. I take satisfaction in tangible outcomes, next steps, and doing. Getting closer to my goal is golden! But this wasn't in me. My voice within was speaking, "Pause." I heard it, even though I didn't want to. I followed the Pause, and this is what I found.

Pause brings peace. The very next day the word within me was Peace. An inner soothing salve that soaks right in. This was a time for solitude, with my thoughts. This wasn't an exclusion of community, but it was a focus on my inner core. Not keeping tune to fillers of time, meet more people, be busy, fill the hours.

Pause takes patience. I couldn't push it or rush it, so I just received it. Learn from it. You don't get to push the pace that isn't always yours to set. Just wait. Pause. Listen. Hear.

Pause is an inner action. A friend pointed out that pause doesn't mean inaction. Yes! Right, I haven't stopped. But it's a time of reflection and increased spiritual discipline, not a time to check off the to-do list. There is a time to move, a time to hold, a time to rest and a time to pause. Maybe, like the seasons?

And just as I knew the time for pause, I'll know the time to un-pause, to hit play again. What I've learned in my time of, and time for, pause is:

· Pause brings peace.
· Pause takes patience.
· Pause doesn't mean inaction.
· Pause is an inner action.
· Pause is preparation.

Stay True to Your Faith

Kansas City, Missouri | 2019

Many people won't understand. Some people will think your choices don't make sense. Especially in today's material world for what "most people" view as important. But you know, when your heart is changed and you believe in faith, you stay true to it.

It's being authentic to you. It's not an option to live otherwise. If your faith is true then it will be reflected. Not just when it looks good and is simple. But when it's hard and it's not where you thought you'd be at this age.

Faith is a road map. The Bible as a life strategy. It's the original motivational speaker. Do good, help others, keep good thoughts, speak good words, pray, ask, seek, love.

To believe in something is to then follow it. Yes, that's where the tension can come in, you mean, to live in my faith? Not just on the easy principles, but the ones that test you?

When your heart is truly changed, what used to be comfortable, isn't anymore. More is expected. And it comes from within.

Stay true to your faith.

Superhero

Kansas City, Missouri | 2019

You are a superhero. This cross reminds me of our inner power. Yes, you can fly!

This white cape, flowing from takeoff, as you launch and leap. Grace helps give lift and faith blows to keep you going. Do you feel it? It's not always smooth. Those puffs of faith aren't always measured for our enjoyment. A sudden drop can make us question our skills. That's where we have to lean into the renewable energy of faith. Like a super hero, you have to mix up your armor. You can't rely on just one. I have found a certain power in faith.

I speak from a place of spotty power. Full strength, but at times I fail and am shaken. Following faith is not always easy. You have to recharge the powers. And to do that I listen to my inner voice. Make sure it is a good voice. "Get up, Amy. It's your move." I choose to double down on the muscle of faith. I've had and have failures. The devil likes to remind me. I have to fight within and say I'm not listening to the negative. I will not live in the past. 'Keep looking up Amy!' I turn to 'my armor – the belt of truth,' the Good Book.

I've found to recharge, I have to pull from a place of strength. Meditate on scripture or motivation that speaks to you. If stuck, get moving. Exercise your mind for strength. Exercise your body to feel a place of strength. While I don't have the power of flight or bulletproof armor, we can all turn to the "belt of truth, the breastplate of righteousness, and our shield of faith," (Ephesians 6:14-17).

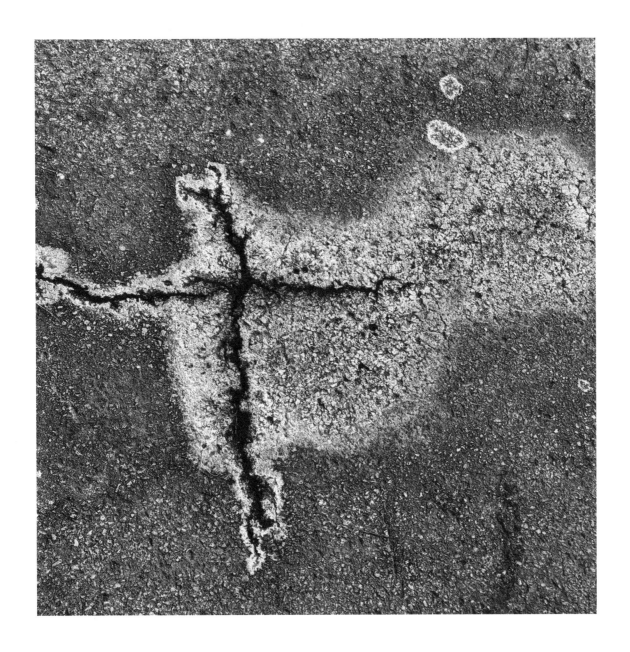

Evolve

Kansas City, Missouri | 2019

Last year my word was Follow. But I didn't. Follow faith. In many ways I did, but sin is sneaky and can overshadow the best attempts. I listened to words instead of the Word.

This year my word is Evolve. It came instantly as I thought about the seasons in life and the standards I have established for myself, as a woman of great faith. It's not always easy following what you know and believe. Oh, and there are sooooo many grays to be found in the spectrum of practicality.

I've found it takes real hard core strength, like muscles, to live your faith. It's easy to *say* you are faithful, or to *say* you practice the Good Book principles. What actions do you take to live faith?

That's the great thing about faith, grace. You gotta turn to it for strength. So my "Follow" transformed into "Evolve" and I took the step for faith.

I Evolve.

Evolve Definition: *"Develop gradually, from a simple to a more complex form. syn: progress, advance, mature, grow, expand, transform, adapt," (Oxford English Dictionary, n.d.)*

Cross Lines

Kansas City, Missouri | 2018

Being wired to the world, instead of wound around the Word.

Vertical and horizontal lines from the electric pole shadow cast a showing of faith. They speak to me, "You are rising up." Making a bold statement: "I Am here. I Am looking over you. Why do you doubt?" Oh, that thing called patience and trust. Vertical and horizontal lines etched within the brick building brings a reminder of the cornerstone of faith. When in doubt, I keep looking up and I find these symbols of faith.

This everyday cross, with cross upon cross, reminds me that sometimes it can feel like the lines in life try to hold us down, cut us off, or pull us away from meaning. Through it all, the Cross is solidly there as our support, our strength, and our beacon. Our rise above! Not a hollow shadow, but a solid form lining our hearts. It's for us to shape the lines of faith, fill in with trust, color with hope, and create with persistent prayer. May our cross lines be full.

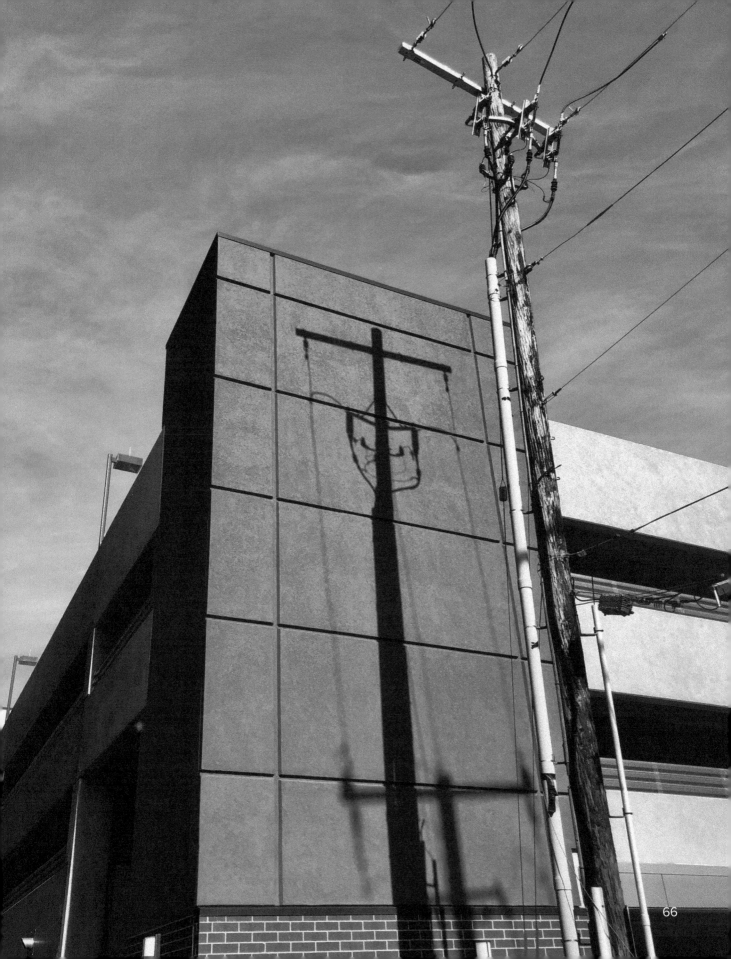

Debris

Kansas City, Missouri | 2018

Hidden? Or just waiting to be seen?

Walking by this vacant spot, I stopped and knew. Where would You be? My eyes scanned the area ... not in the broken concrete, torn rebar, loose rocks, broken bricks of former walls, but there.

Yes, the wood of 2x4's formed the Cross. And I smile. I just knew. Have you experienced this feeling? Knowing the presence is there, but not seeing?

Faith in knowing. And then finding faith by sight.

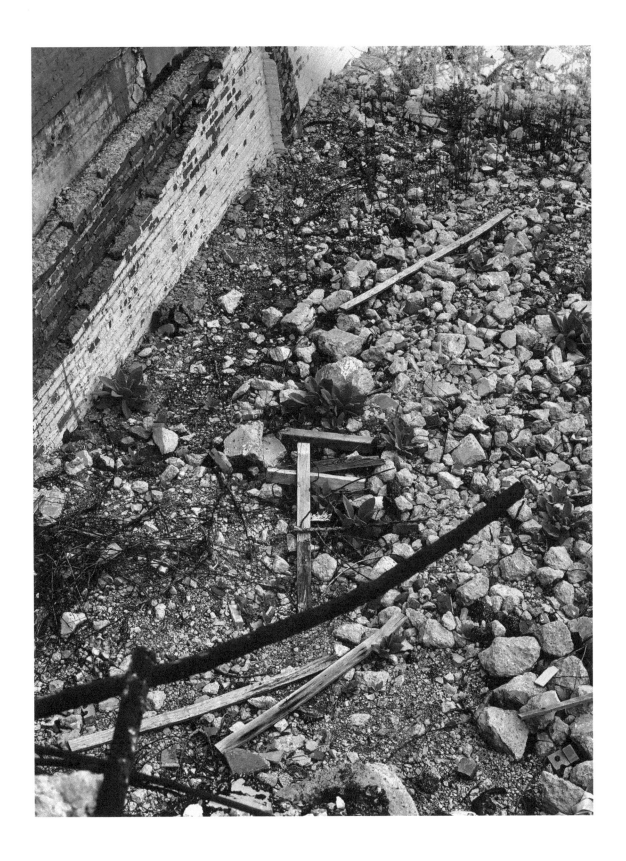

Rising Up

California, Missouri | 2018

You're really kinda ugly.

And that's how I've felt at times in my life. From my own ugly thoughts, behavior or someone else's negative words, reminding me of all I am not. Pointing out my faults in less than pretty ways, instead of seeing my strengths.

But even in this non-image, I see beauty. Like the ugly we have going on around us, we have beauty.

We have something more than what others may see or value.

We have the power to renew. To rise up. The rising up kind of faith. And I see the beauty.

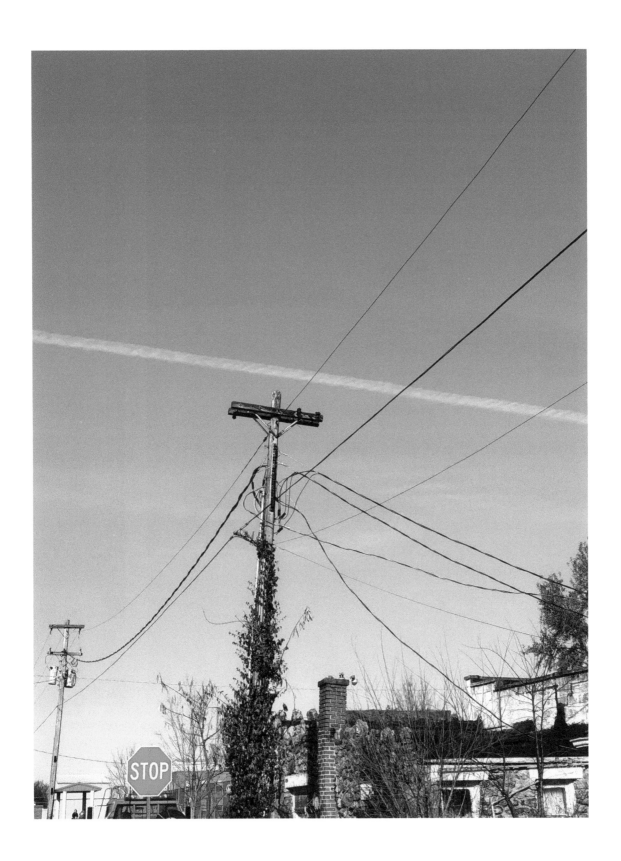

Arise

Kansas City, Missouri | 2018

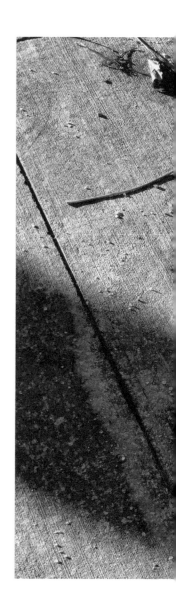

Dear one, you are so much and more.

Don't let anyone tell you otherwise. That you aren't enough.

That you don't have this and you don't have that.

Don't listen to it. Don't absorb it. Those external or internal voices.

Rise above dear one. Rise to me.

I have more for you. I have plans for you.

I know your faithfulness. I see you. I hear you.

Arise with me dear one. I Am with you.

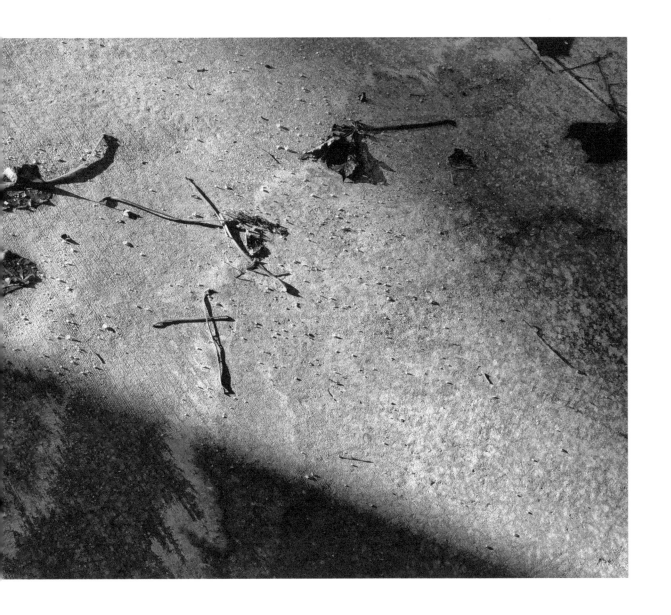

Ceiling Crosses

Kansas City, Missouri | 2017

Do you ever wonder if it is just you? Is it just you seeing it? Does anyone else see? While I was working out it happened again. And it keeps happening. When you see something that is around, but you see it anew? For me I keep seeing crosses. Crosses in nature and in forms and shapes that are not traditionally meant as a cross.

This one came while I was resting from the leg press machine. I look up with my head fully tilted back on the head support and there You are. I was in need. In need of my spirit being lifted. I was praying. And I look up and there You are, crosses covering the ceiling. You speak to me: Here I Am. Don't you know that already? I Am here. Why are you worried, why are you anxious?

It keeps happening. And I love it. Sometimes it doesn't surprise me; I expect to find cross images in new places. I don't know when and where, but You keep appearing. "Seek and you will find" (Matthew 7:7). It shows me to keep turning towards faith. Keep looking above. When you are down, look up. It is having faith.

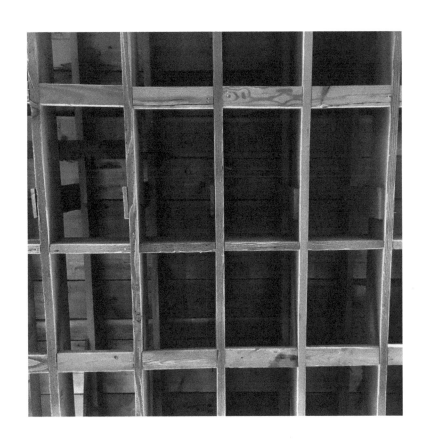

Giving Tree

Kansas City, Missouri | 2020

Finding faith in my everyday surroundings. Especially nature.

Timing.

The right time of day. The right time in a season. A few days later the growing leaves would have covered the branches.

But it was the right time, allowing the sunlight to illuminate this image.

Made for me.

Photos on page 77/78 — Kansas City, Missouri | 2018 — Kansas City, Missouri | 2017

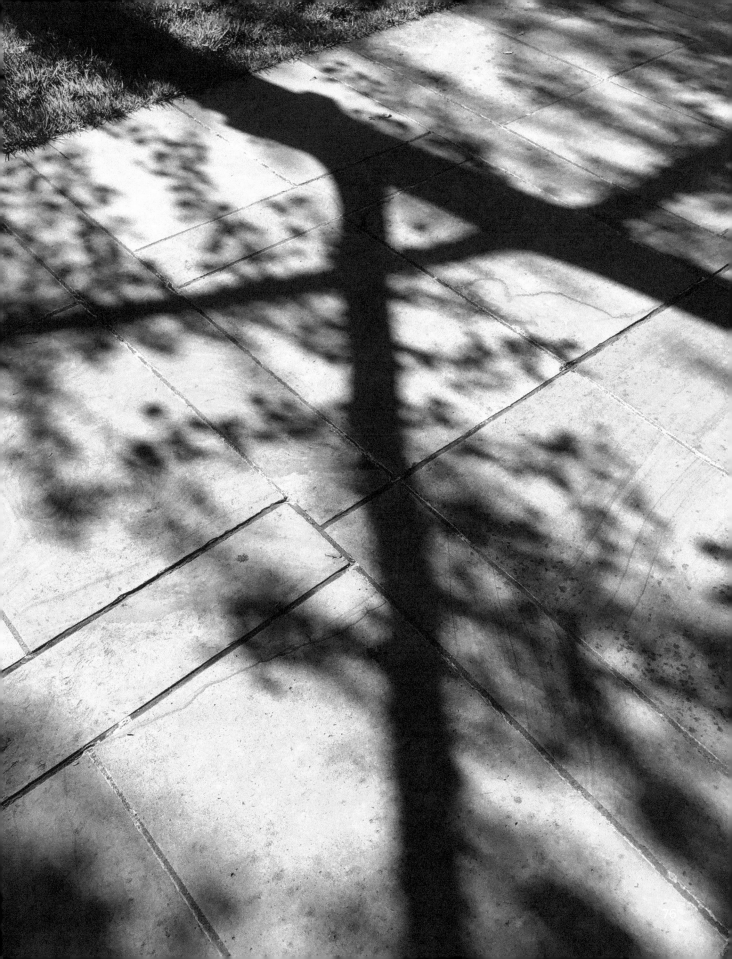

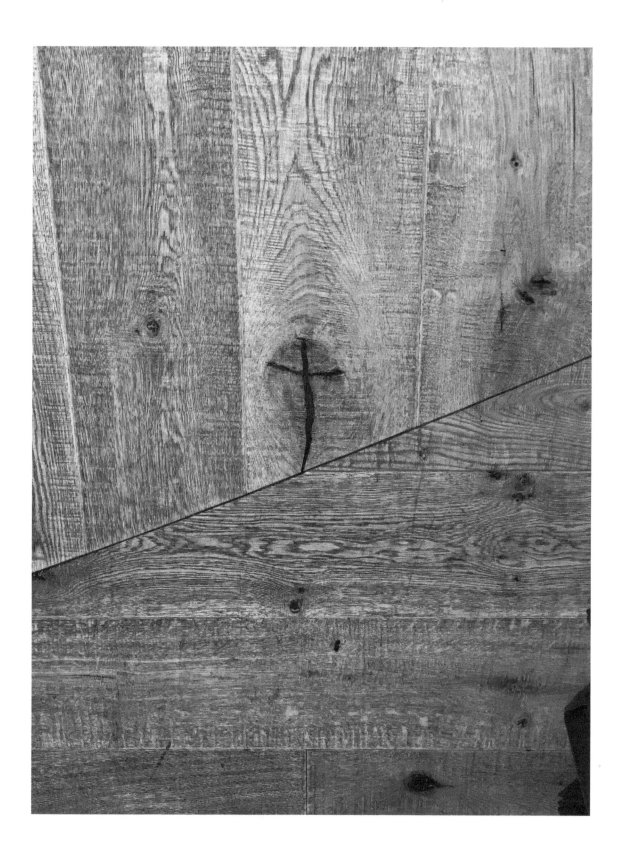

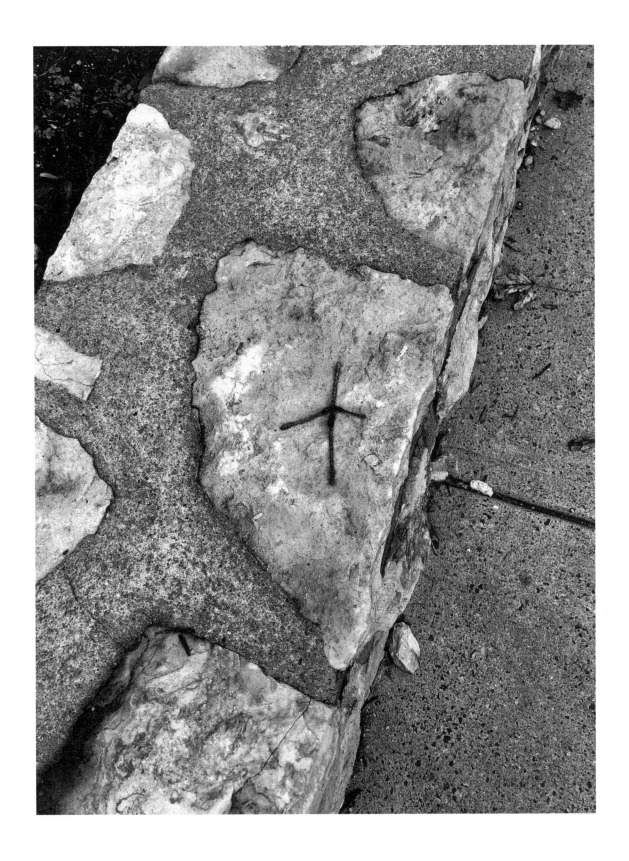

Shadow Sign

Kansas City, Missouri | 2019

Believe in the voice of faith.

Trust in the signs received.

It takes strength to get, and to stay, on the path you see, hear, and believe.

The voice of faith can be quite. The signs are subtle.

If you listen and follow, a steady pattern appears.

You have a choice. The challenge is to accept it or avoid it?

Believe in the signs of faith.

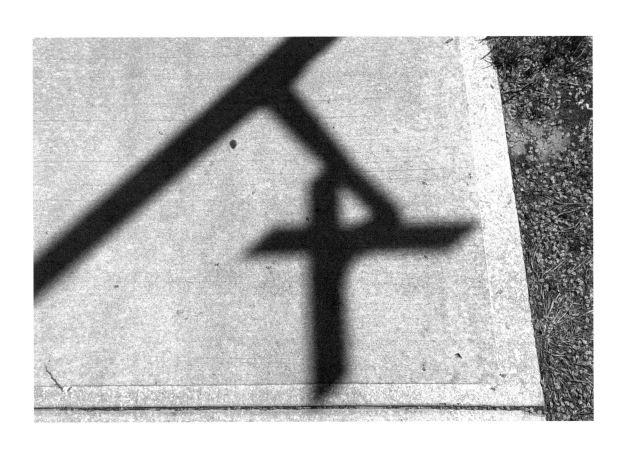

Faith Moves

Kansas City Missouri | 2020

How much is enough? You just need to have some faith.

At times a little drop of faith will get you over the top.

But sometimes it takes a whole lotta extra hubba-bubba sized, overfill-my-bucket load.

You know what I've found? Action brings faith. Sitting around doesn't build it. Know your time to pause and time to move.

Waiting doesn't inspire faith within. Live your faith, whatever that is. Whether you need faith in self, faith in a higher power, faith in others, you must move off the dot!

Taking even a little step brings movement. And momentum begins.

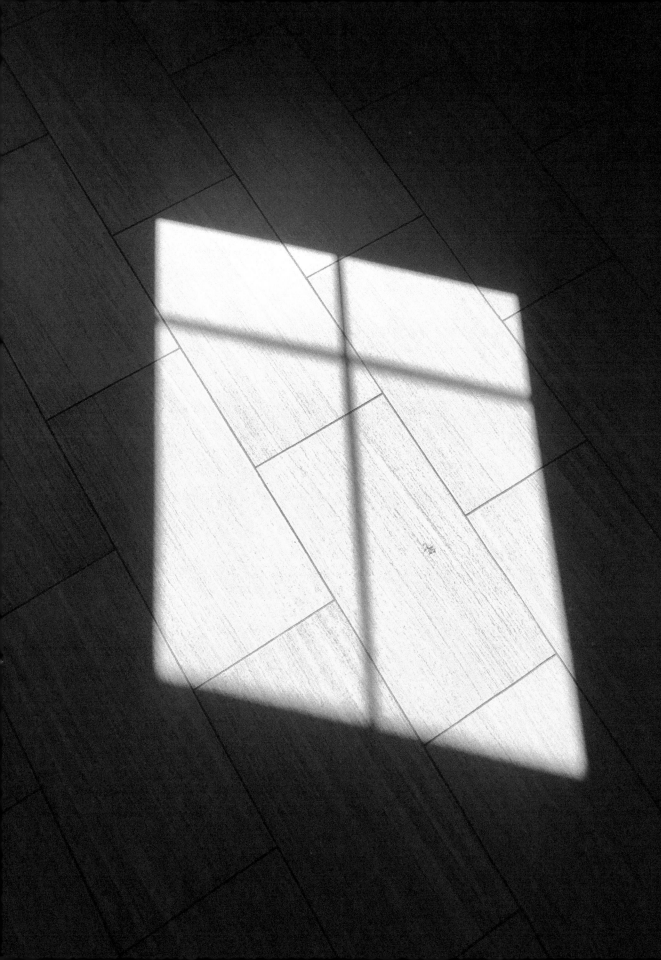

Images Ahead

Kansas City, Missouri | 2018

I used to define myself as a cyclist. For eight years, I was all this. I lived it. The bicycle lived in me. I couldn't get enough of the miles and the liberating freedom of the self-generated speed.

And you better bet that even when you are exhausted, when you see a dog sprinting from afar to meet you on the road, you do have more energy!

Then I needed more, amateur competitive cycling and joining a race team. Going to clinics to learn how to "corner," not just make a turn. Road races, criteriums, and cyclocross. I trained. I defined myself as a cyclist. I went to a cycling camp for vacation. My weekends were based on cycling.

Pushing yourself physically and mentally. Learning how to train, the nutritional aspect – on and off the bike, the mechanical side, breathing, learning technical factors, recovery. Making friends with hills. Seeing up close nature and the change in seasons. Bike religion.

But then I wasn't rejuvenated by it. And I stopped riding. I felt the need to slow down. Take walks. Enjoy nature at a slower pace. It took me awhile to let go of my self-definition of being a cyclist.

And when I did listen to that voice and let it go, something else entered. From taking pulls on the bicycle to taking photos.

Don't hold onto something that isn't in your season. Because when you open your mind to new, you just never know the image ahead.

Photos on page 85/86 – Highway I-70 between St. Louis and KC | 2018 – Kansas City, Missouri | 2018

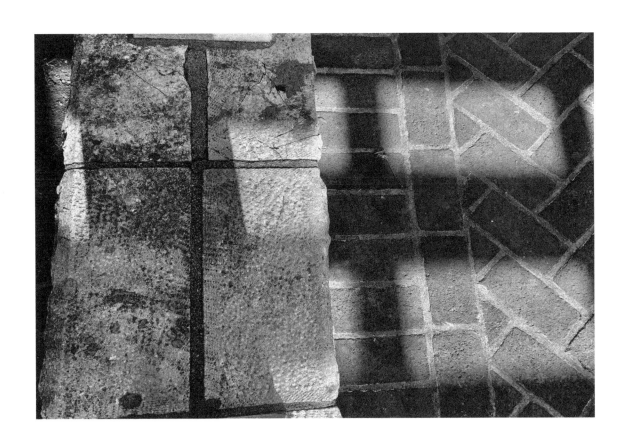

Repeats

Kansas City, Missouri | 2020

While doing stair repeats for exercise, I didn't notice this little cross until my fourth round. Hello. Looking right at me.

Each time I find and see an everyday cross I receive it as a gift. This one was extra special because it appeared on my birthday. For me. My special gift of love.

Faith is all around for us to see. We just have to slow down, pay attention, and see what is right in front of us.

Photos on page 89/90 – Kansas City, Missouri | 2019

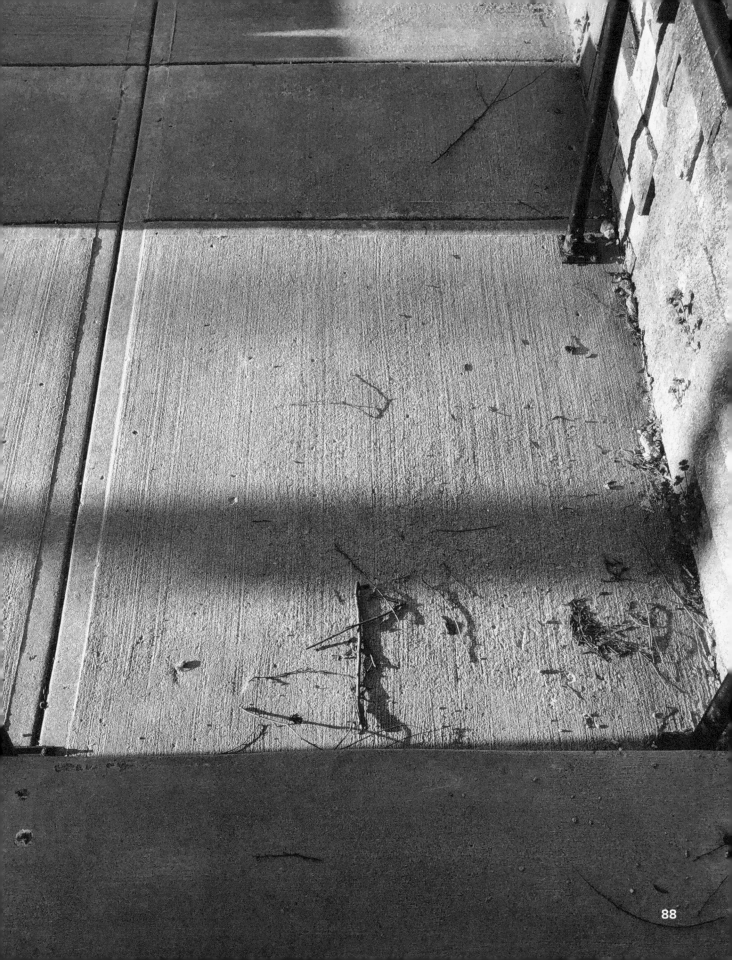

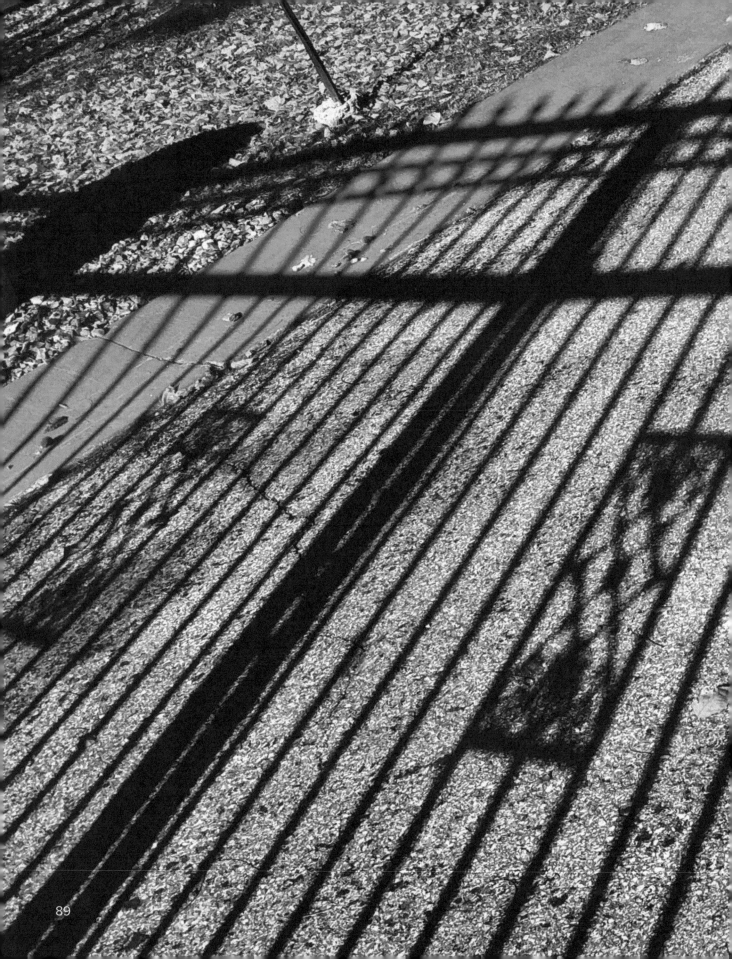

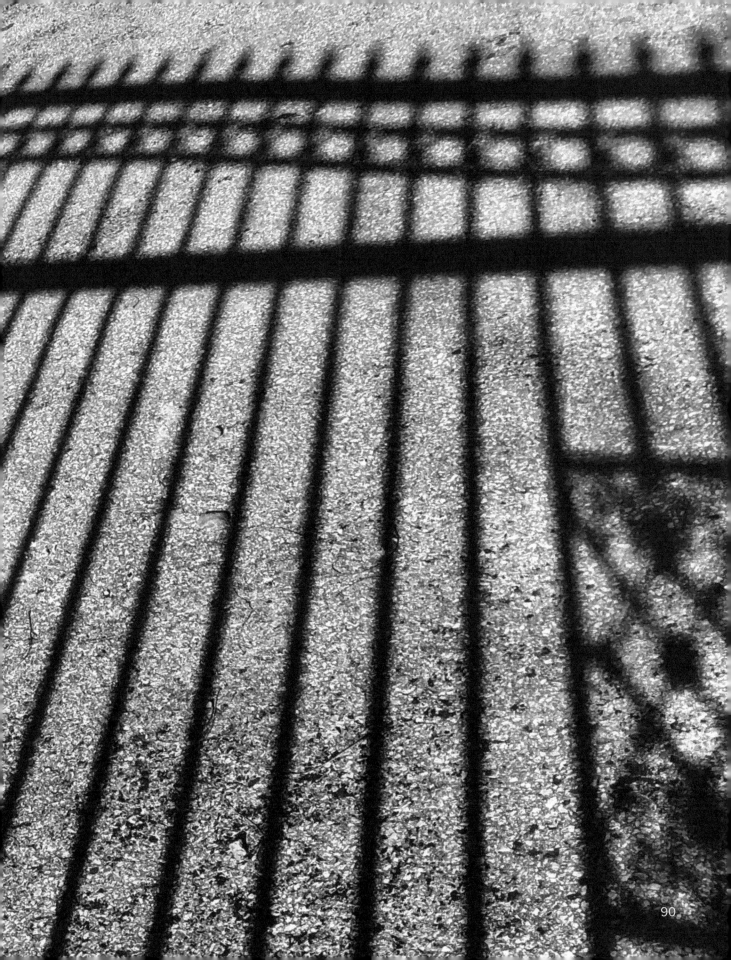

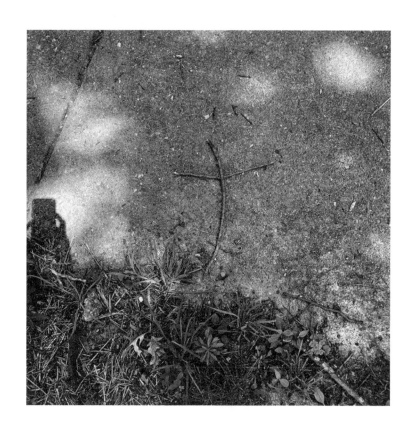

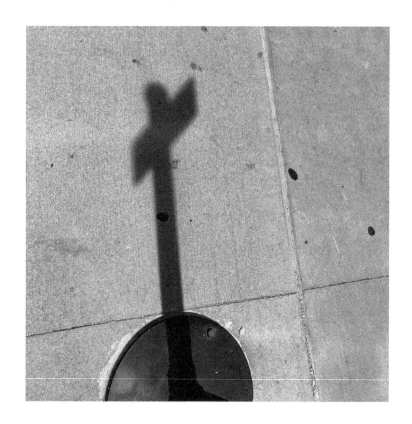

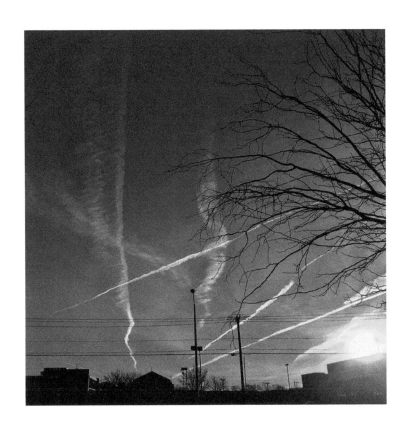

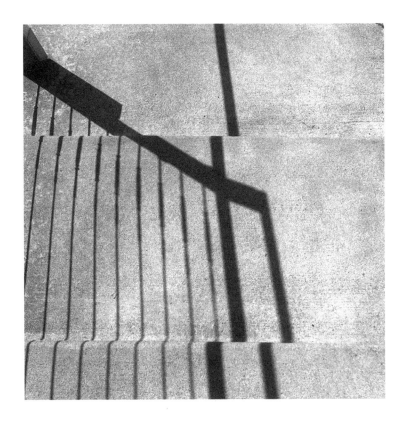

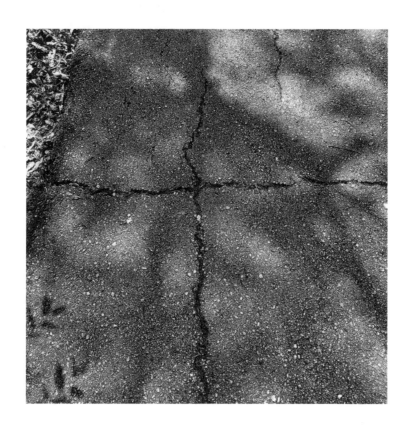

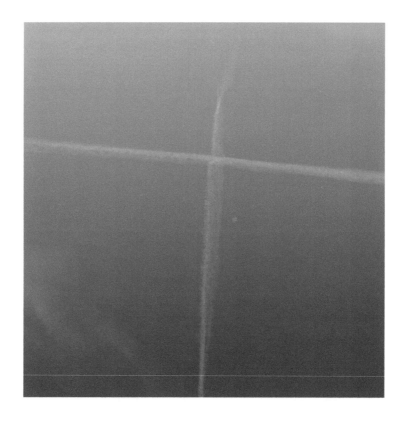

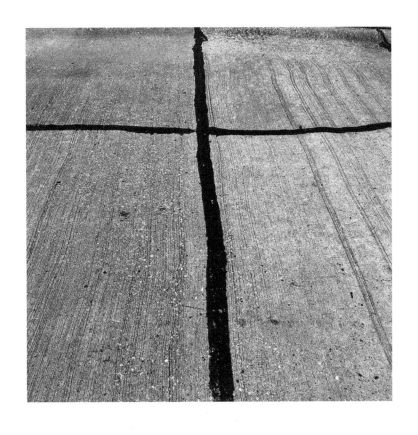

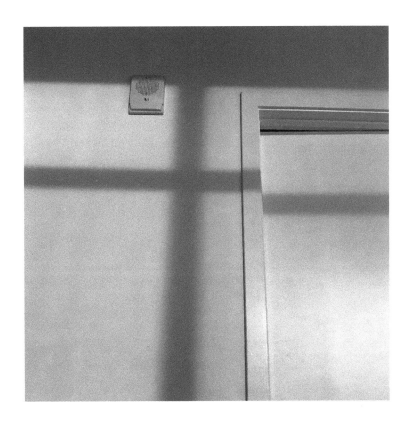

It Feels So Big, And Me So Small

Kansas City, Missouri | 2018

This idea, goal, dream. It's just little 'ole me.

Steps 1, 2, 3 and the hundreds other, done with trust, perseverance and discipline.

That's what faith is about, right?

But now, this one seems bold. Well, I believe and trust. Yet the devil of doubt enters trying to keep me in my comfort zone.

To not step out.

So I will turn away from the negative whispers. It's my path.

Even when I don't know what's ahead, when I don't know the how.

Not by sight, but by faith.

Be strong and have courage.

I will keep looking up!

Take The Next Step

Kansas City, Missouri | 2020

Even when you don't know all the hows. Trust.

Even when you don't know the outcome. Trust.

Take the next step. I'm right here. I won't let you fall.

"Take the next step." That is the message I see, and received, in this found everyday cross. Timed for me.

I will take the next step.

Behind the Photo
This is a special photo. During a morning walk, I prayed and asked for a sign. I said "I know you've shown me time and time again, realizing it's silly for me to even ask, but yet I do. Help me to know." Ending my walk I took a different path, going down a set of stairs there was my sign. Laying so gracefully. It spoke to me. And I listened. My next step was to produce this book.

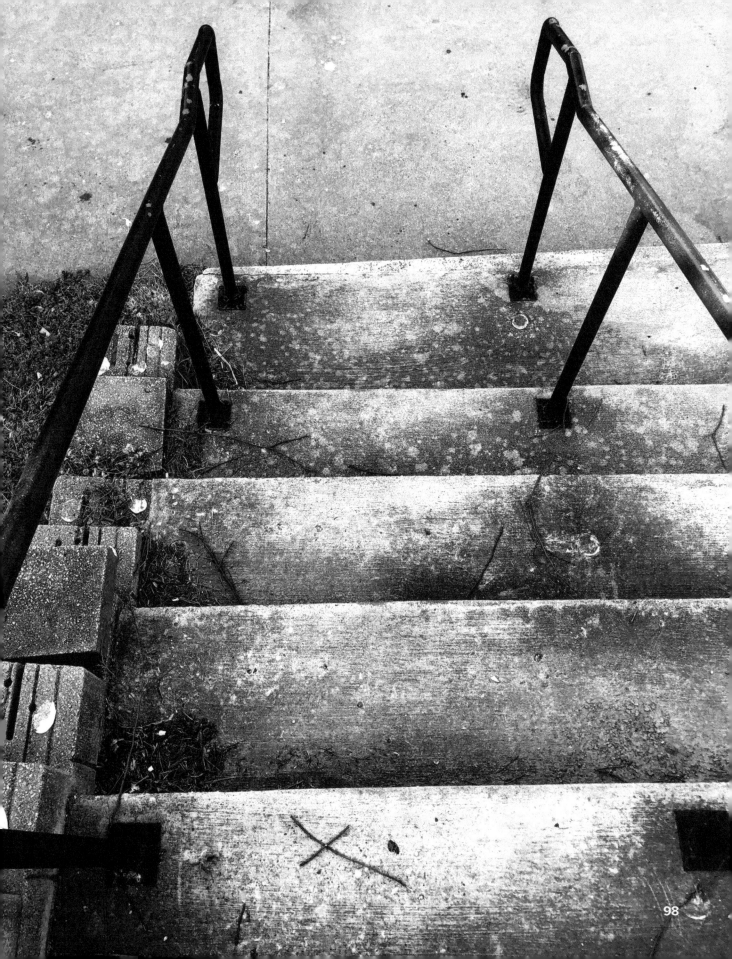

Solo Exhibitions

2019, Beggars Table Gallery, Kansas City Crossroads Arts District First Fridays, Kansas City

2019, Zelis, Selected artist in the ArtsK Regional Council Now Showing Program, Kansas City

2018, Pathways United Methodist Church, Springfield, Missouri

2018, Steeple of Light Art Gallery, Kansas City

2018, Central United Methodist Church, Kansas City

2017, KTK, Selected artist in the ArtsKC Regional Council Now Showing Program, Overland Park, KS

"Your photographs are beautiful. Each work evokes a feeling of spirituality! They are all so meaningful." **- Rev. Adam Hamilton, Church of the Resurrection**

"This was the first thing in my timeline this morning and couldn't have been more heaven sent. Brought tears to my eyes. Sometimes we just need a reminder." **- Angelina Blanks**

"The signs truly are everywhere! Thank you for showing them to us!" **- Elizabeth,** *Blue Jean Gypsy*

"In this materialistic, cynical world, Amy's inspirational message is that it doesn't have to be that way. We can choose to step off the well-worn road and find the path God wants us to walk, pursue the passions that make us joyful, and live a meaningful life of purpose and love." **- Shirley Gilmore, Pathways Church**

"Amy was able to challenge us to rethink our understanding of the cross. The symbol of our faith, is not only contained in specific places designated for the faith to be practiced, but experienced and present in obscure and easily overlooked spots. The passion she brings to the topic is palpable and contagious. She helps open our eyes to see the cross wherever we go." **- Rev. Trevor Dancer, Central United Methodist**

"Amy does a great job finding meaningful images and capturing them in a striking way!" **- Erin Albright, Steeple of Light Gallery**

"Since coming across Amy's beautiful and powerful images, I make an effort to notice and look for how God is everywhere in our lives, the crosses just help me remember His love." **- Trina Taft**

Acknowledgements

A deep thank you to the community of women who consistently helped and cheered me on at the many stages and evolutions of this idea. Foremost, is Aphrodite Platko, who was at the very first step of the initial idea and she has been at every step. Two other key women who provided help at the right times, moving me along in the process when needed are: my mother Judy Bretall and Gayla Guthrie. Others I'm grateful for their time and help: Karen Thompson, Jennifer Ortmann, Shirley Gilmore, Kate O'Neill Rauber, and Jane Walton.

These women showed me how important community is to reaching a goal, because we don't do it alone.

A special acknowledgement to the power of faith and the power of prayer — my story is a testament to this combination. At every step of this evolving project/mission, it took faith and prayer to see the signs and follow them. I hope this book inspires others to see faith in the everyday and to believe in faith.

Photos on page 91 - (top) St. Louis, Missouri | 2019 – (bottom) Kansas CIty, Missouri | 2019

Photos on page 92 - (top) Kansas CIty, Missouri | 2018 – (bottom) Kansas CIty, Missouri | 2020

Photos on page 93 - (top) Lawson, Missouri | 2019 – (bottom) Kansas CIty, Missouri | 2019

Photos on page 94 - (top) Shiloh, Illinois | 2019 – (bottom) Kansas CIty, Missouri | 2019

Other Photography Collections

Cuba Collection

"Dos Crosses", Havana, Cuba - 2015

A Chance Meeting. During a cultural and humanitarian delegation, Amy met a 10 year-old girl in Cuba in October 2015, outside of Ernest Hemingway's home. Turning around, there she was. Returning home to Kansas City, Amy was inspired to raise money to help her have a better life. Cuba is a third world communist country where food is rationed and residents live in very poor conditions. Amy kept thinking what she could sell to raise money. In March 2016 the idea came to Amy to turn her photos into card gifts as the vehicle to sell and help the child. Proceeds from the Cuba Collection go towards helping the young girl and family.

Faith Collection

"Family of Crosses," Kansas - 2016

Reconnecting with the faith from her own childhood and reading the Bible for the first time in January 2016, Amy was compelled to take photos of crosses. In an expression of her faith journey, she started noticing, and took photos of, crosses everywhere, in the urban core; the inner city; the suburbs, and rural areas, with no intent to do anything with the photos. Following faith and the desire to help a girl in Cuba, her first idea was to use some of her photos of "formed" crosses and turn them into cards to sell to help the girl. As Amy followed faith, her idea expanded.

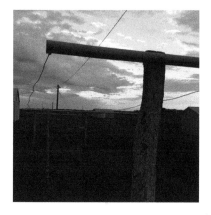

Rural Collection

"Wash Line," California, Missouri - 2015

Roots on the Farm. These photos are special because they are from Amy's grandparents farm in California, Missouri. Growing up she and her sister would spend time on the farm creating memories. After living in the same farmhouse for 72 years, Amy's grandmother sold the farm in 2015. Visiting her grandmother and the farm the final few times, Amy couldn't help but take photos of all the natural beauty. A farm girl at heart, Amy was drawn to the images and now enjoys sharing the beauty of rural America she holds dear. The Rural Collection images provide a feeling of hope, home, peace, and comfort of a past time and the opportunities ahead.

About the Author

Born and raised in Missouri, Amy resides in Kansas City, MO. With a professional background in business and Human Resources, photography found her while she was developing her faith.

During a 2015 cultural and humanitarian delegation in Cuba, Amy met a young girl. An instant bond was formed. Moved by the girl's difficult living conditions, Amy set out to develop a product to sell to help her and her family. What started with turning her photography into greeting cards has grown into Amy's mission to inspire faith. Her blog, photography, social media, gifts, and books are designed to inspire others to seek and see faith in everyday life.

Amy is striving to become a woman of great faith. Her motto is "The little things in life are big." She can now mark this book, *In Plain Sight,* off her Heaven To-Do list.

Follow on Instagram @livebreathealive
Read and find more at: LiveBreatheAlive.com

CPSIA information can be obtained
at www.ICGtesting.com
Printed in the USA
BVHW020344121220
595569BV00022B/1304

9 781735 822600